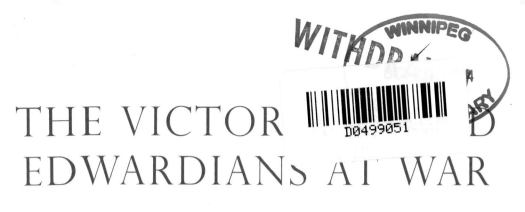

THE VICTOR
EDWARDIANs at WAR

John Hannavy

HENRY DIXON, Photo.

SHIRE PUBLICATIONS

Published in Great Britain in 2012 by Shire Publications
Ltd, Midland House, West Way, Botley, Oxford OX2 0PH,
United Kingdom.
44-02 23rd St, Suite 219, Long Island City, NY 11101
E-mail: shire@shirebooks.co.uk www.shirebooks.co.uk

A CIP catalogue record for this book is available from the
British Library.

Shire Library no. 674 • ISBN-13: 978 0 74781 133 6

John Hannavy has asserted his right under the Copyright,
Designs and Patents Act, 1988, to be identified as the
author of this book.

Designed by Tony Truscott Designs, Sussex, UK
and typeset in Perpetua and Gill Sans.
Printed in China through Worldprint Ltd.

12 13 14 15 16 10 9 8 7 6 5 4 3 2 1

COVER IMAGE
From Max Ettlinger's 1905 'Royal' series of tinted
postcards, 'Life in our Army', the Black Watch, Royal
Highlanders at camp. The series included at least one
postcard for each regiment in the Army.

TITLE PAGE IMAGE
Studio portrait of a British Field Marshal, believed to be
Sir John Fox Burgoyne Bt, taken by London photographer
Henry Dixon in 1868 at the time of his promotion.
Burgoyne was already a Major-General when he was sent
to the Crimean War, during which time he was involved in
the siege of Sevastopol, and the assault on the Malakoff
Fort. A few weeks before the siege, he was one of the
many senior British officers to be photographed by Roger
Fenton.

ACKNOWLEDGEMENTS
The author thanks the following people and institutions for
permission to reproduce photographs from their
collections as follows: Adrian Greaves Collection, pages
78–9; Archive of Modern Conflict, pages 40–1, 83;
Beinecke Rare Books and Manuscripts Library, Yale
University, page 37; Christie's, London, pages 68, 69
(top), 72–3, 76–7; John Toohey Collection, pages 64–5;
National Army Museum, page 67; National Gallery of
Australia, page 70; Private Collection, page 69 (bottom);
The Royal Collection, © Her Majesty Queen Elizabeth II,
page 38. All other images are from the John Hannavy
Picture Collection. www.johnhannavy.co.uk

CONTENTS

PREFACE

The Royal Navy's Cruiser Squadron moored off Rothesay in 1904, amongst them some of the recently introduced four-funnel 'Cressy Class' cruisers. Many postcards of the Clyde estuary during the Edwardian era show large numbers of warships at anchor.

A small coastal puffer sails past another group of warships, this time anchored in Lamlash Bay off the island of Arran in 1903. Naval squadrons were regular visitors to the waters off Arran. Officers on shore leave were even granted free membership of Lamlash golf course whenever their vessels were in the bay.

IT WAS ONLY to be expected that the art of photography would be applied to war as soon as cameras and processes were capable. In focusing on the wars in which Victorian and Edwardian Britain engaged, I am picking up threads of research which have interested me for nearly forty years. The Crimean War and the photographs taken of it by Roger Fenton have occupied a large part of my life – since I started work in 1971 on the research for the Scottish Arts Council exhibition *The Camera Goes to War*, which began its tour

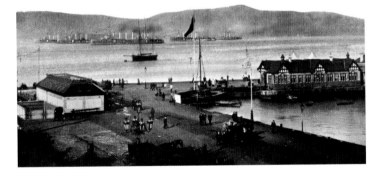

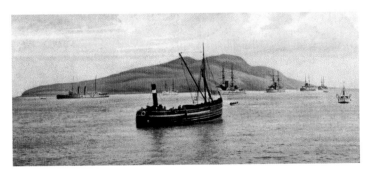

in Edinburgh in 1974 and completed it at the National Portrait Gallery in London in late 1975, the year my biography of Fenton was published. Since then, the photography of war has remained one of my abiding fascinations.

As ever, my thanks are due to everyone who has answered my endless questions over the years, especially to those who have alerted me to the availability of splendid images, or pointed me towards engaging contemporary accounts of military engagements across the world, for it is those extracts from writers more eminent than myself which makes this more than just a picture book.

I am especially grateful to those individuals and institutions who have generously permitted me to include images from their collections. All other photographs are from my own collection.

Finally, special thanks to Kath, my wife, whose support and encouragement for my ongoing researches is ever-present.

John Hannavy, Great Cheverell, 2012

An unidentified French cruiser at anchor in the Firth of Forth, c. 1895. The closing years of the nineteenth century saw huge changes in the construction of warships, as navies developed faster, more powerful and more versatile designs. The radical hull shape seen here was used on many warship designs in the French Navy at the time, but as the century drew to a close, designs more in line with those being developed by the British – and broadly similar to the pre-Dreadnoughts and Dreadnought designs – started to appear.

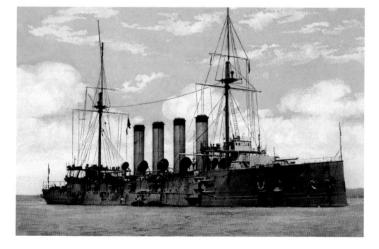

The Clyde-built HMS *Sutlej* undergoing sea trials in 1901 or 1902. Constructed by John Brown, the keel of the 12,000-ton Cressy Class HMS *Sutlej* was laid down in 1898. The yard also built her sister ship HMS *Bacchante*, as well as vessels for the Spanish, Japanese, and Russian navies.

Right: One of the more poignant studies from Roger Fenton's coverage of the Crimean campaign, this view of the cemetery on Cathcart's Hill near Balaclava with the tents of the camp beyond, shows the graves of several high-ranking British officers who had died in 1854 during the early months of the war. Amongst all the portraits and camp scenes, images like this underlined the human cost of war.

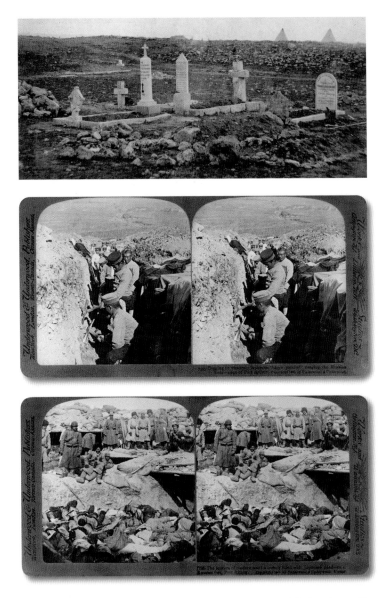

Above and middle: By the end of the nineteenth century smaller cameras and faster materials had made possible something approaching the action images we expect today. Half a century of getting used to the realism of the photograph had also familiarised the public with the real horror of conflict. These two stereoscopic views by photographers working for the American Underwood & Underwood company were taken during the Russian–Japanese war of 1904–05. The upper card shows life in the Japanese trenches while the lower one is captioned 'The horrors of modern war! A trench filled with Japanese dead in a Russian fort – Port Arthur.' The Russians capitulated in January 1905, shortly after these pictures were taken.

THE CAMERA GOES TO WAR

PHOTOGRAPHY was invented early in Queen Victoria's reign, but for its first few years, the available processes were too cumbersome and too slow to be used to record any activity which involved rapid movement. Indeed, for the first few years of the photographic era, those who posed for the camera had to sit still for very long periods of time – often running into several minutes if light levels were anything other than very bright.

So, for many of Victoria's wars, the war artist continued to reign supreme, as he had done for centuries. The stylised and idealised sketches and paintings of the heroics of British forces, both establishing and then policing the Empire, perhaps offered the viewer an image of war which was far removed from actuality.

Just as there was no market for paintings showing the real brutality of battle, so for photography's first several decades, images which showed death were rarely if ever taken. And that draws attention to the unique difference

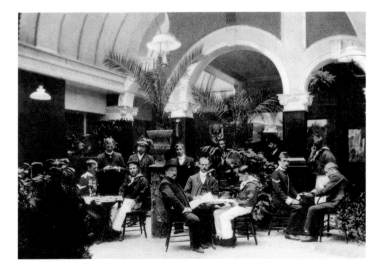

The restaurant in the John Cory Sailors' and Soldiers' Rest Home, c. 1905. The home, endowed by John Cory, a local colliery magnate, shipping entrepreneur and philanthropist, opened in Bute Street in Cardiff in 1901. The uniforms evident in this scene suggest that it catered for non-commissioned soldiers and sailors.

Scots-born Alexander Gardner emigrated to America and made his name through his albums of views of the American Civil War. *What do I want, John Henry*, taken in November 1862 in Warrenton, Virginia, is accompanied by the commentary, 'When fatigued by long exercise in the saddle, over bottomless roads, or under the glowing Southern sun, John's master would propound the query, "What do I want, John Henry?" That affectionate creature would at once produce the demijohn of "Commissary", as the only appropriate prescription for the occasion that his untutored nature could suggest.' (Courtesy of the Beinecke Rare Book and Manuscript Library, Yale University.)

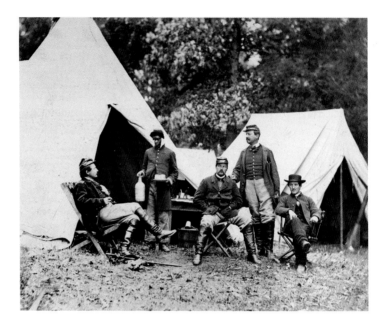

between how Victorians accessed photography, and how we access it today. With television news and heavily illustrated newspapers – the images telling much of the story – we receive images selected by an editor. Having made the decision to subscribe to a newspaper, or turn on the television news, we expose ourselves to image selections made on our behalf by someone we will never meet.

The Victorians, on the other hand, acquired their photographs either by subscription or from print shops, and the commercial success of a photograph therefore depended on the buyer actively making the decision to purchase it. If the picture was likely to shock, or to cross one of the strictly drawn boundaries of Victorian good taste, it would not sell as well. Thus it was that Roger Fenton's 360 views of the Crimean War (discussed later) comprised mainly group portraits and camp scenes, and contained no scenes of carnage or death – absolutely nothing to offend, or to limit the commercial potential of the image.

It was not until Robertson and Beato's brutally direct images from the Siege of Lucknow were imported into Britain in 1858 that the British first saw dead bodies in war photographs. The impact of such pictures was considerable, as the true horror of war had never been photographed before. There is a difference between reading about it, and actually seeing the mutilated and bloated bodies of the fallen.

While a number of eminent photographers produced hundreds of large-format scenes during the course of the American Civil War, many of

the more graphic photographs were taken in 3-D, to be viewed in the drawing room stereoscope. The three-dimensional horror of the battlefield was thus made even more vivid, but at least the images were not usually on display, and the small format of the stereocard allowed it to be discreetly housed in a book-shaped box, hidden away from the casual glance of the more sensitive viewer.

Arguably, the craze for collecting and viewing stereocards of all subjects did more to promote realism in photography than the buying and collecting of large-view prints. And the popularity of the stereoscope lasted a great many years from its heyday in the 1850s and 1860s. Well into the Edwardian era, stereoscopes were still to be found in many drawing rooms, and images of the early wars of the twentieth century – by then much more frank and shocking – were available worldwide.

Albums of photographs from the American Civil War were available for purchase in Britain, the most notable being Alexander Gardner's *Photographic Sketchbook of the War*. This contained several of the more graphic scenes of death ever seen at the time, and also one of photography's earliest controversies, for

Alexander Gardner's *Home of a Rebel Sharpshooter*, taken in July 1863 after the battle of Gettysburg. The body had earlier been photographed in an open location nearby, suggesting Gardner had moved it to create a more striking photograph. As a result, the corpse was not found or buried for over six months.

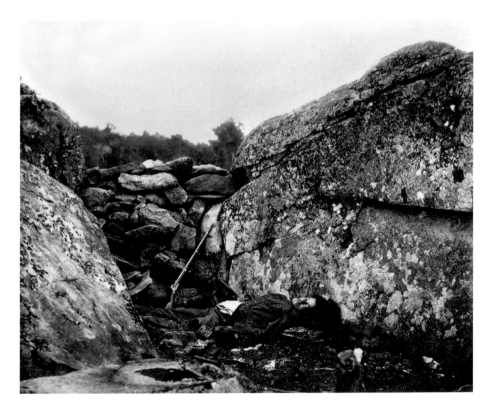

The ambrotype process, also known as the 'collodion positive', was a modification of the wet collodion process, in which the negative plate in the camera was developed as a unique positive image, before being tinted, gilded, and fitted into a case. As the image is carried on the plate exposed within the camera, each is unique. The collodion positive was cheaper than the daguerreotype portrait and made photography affordable to more people, but it was still too expensive for most. The two portraits shown are cased in sophisticated thermoplastic 'union cases', a more expensive alternative to the morocco leather case usually used to protect such images. No information survives as to who the boy soldier or the bugler were, where they came from, or to which regiments they belonged.

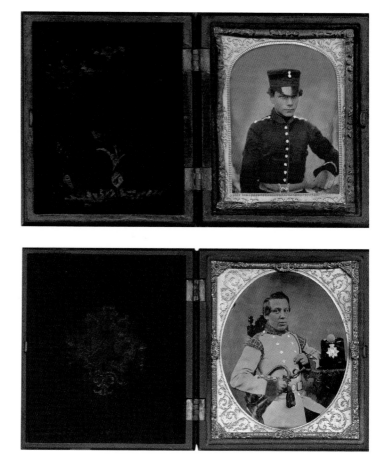

Gardner had moved a body into a narrow rocky cleft in order to produce a more potent image of the Battle of Gettysburg, effectively constructing a scene which, while it might have represented a typical view, was no more an accurate record of the conflict than any painting produced by a war artist. Controversy and debate over several of Gardner's images continue to this day.

In Victorian times, all photographic prints were made in contact with the negative. If a large print was needed, then a large glass-plate negative was required, and an equally large camera in which to actually make the exposure. For small 3-D stereoscopic pictures, the requirement was for small prints from small plates and small cameras. Most photographers carried a considerable weight of equipment and materials with them on location – several cameras, glass bottles of chemicals, an assortment of different-sized glass plates, processing dishes, and much more.

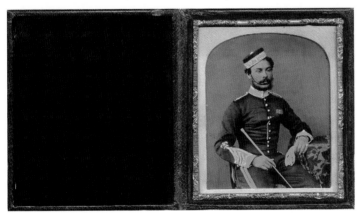

A quarter-plate (*top*) and a sixth-plate (*middle*) ambrotype of a regimental Sergeant Major in the 17th Lancers in the 1850s, housed in high-quality leather cases. Since the pictures were taken, much of the tinting has faded, leaving only the gold leaf applied to braid, buttons and cuffs, and a little colour in the ribbons. Tinting and gilding portraits in this way was a skilled art, adding to the cost of being photographed. The quarter-plate image is oldest and, typical of many ambrotypes of the period, the soldier is laterally reversed – his ribbons are on his right breast rather than his left, and his tunic buttons on the wrong side. Such shortcomings were considered unimportant.

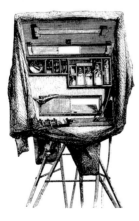

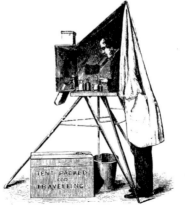

Some highly innovative solutions to the wet collodion photographer's need for a darkroom on location were available – on the left is a collapsible darktent designed for use in locations where a larger darkroom was impractical. Even smaller and lighter-weight tents were marketed throughout the period.

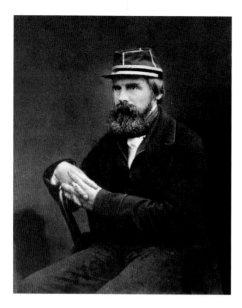

Roger Fenton, wearing a borrowed kepi, after his return from the Crimean War. Fenton photographed William Howard Russell, the famous *Times* correspondent, and William Simpson, the war artist. Simpson's sketches and paintings of the war complement Fenton's photographs by capturing and interpreting action that the camera was incapable of recording. Despite their place in history as the world's first substantial body of war photography, Fenton's pictures are, more accurately, 'at war' rather than 'of war'.

From the early 1850s, most photographs were taken using wet collodion, a cumbersome and quite complicated process which involved considerable manipulative skill and some fairly toxic chemicals. Collodion itself was made from gun cotton dissolved in ether, the fumes from which were both injurious to health and addictive. Surprisingly, collodion was also an extremely beneficial material to have in a war zone – as it dried, it created a thin and reasonably impervious membrane, and was widely used as a field dressing to keep wounds clean in the filthy conditions of Victorian battlefields. Its application to photography came about as a result of experiments by Frederick Scott Archer to create an early film.

The wet-collodion photographer or his assistant had to prepare and coat each glass plate just before taking the picture, expose it while the light-sensitive chemistry was still tacky, and then develop it immediately after exposure.

This meant that the photographer had to take his darkroom with him wherever he went, and some highly ingenious collapsible darktents were marketed to fit the purpose. Most professional photographers, however, took a more robust facility with them, and in the case of Roger Fenton, his pioneering trip to the Crimea involved a large and fully fitted-out horse-drawn darkroom van which he first put through its paces in the Yorkshire Dales in the summer and early autumn of 1854.

The van served as both darkroom and living quarters while his driver William, and his assistant William Sparling both slept outdoors underneath the wheels. Considering the chemistry involved in preparing and processing wet-collodion plates, they probably had the better deal!

In his account of his experiences, delivered to a packed lecture room at the Photographic Society of London in January 1856, Roger Fenton gave his audience a list of the materials he had taken with him on his journey to the Crimea – a list typical for any long photographic trip with collodion. His account is meticulously detailed:

I took with me a camera for portraits fitted with one of Ross's 3-inch lenses, two cameras made by Bourquien of Paris, of the bellow construction, and fitted with Ross's 4-inch landscape lenses, but in place of which I subsequently employed a pair of Ross's 3-inch lenses with which I had

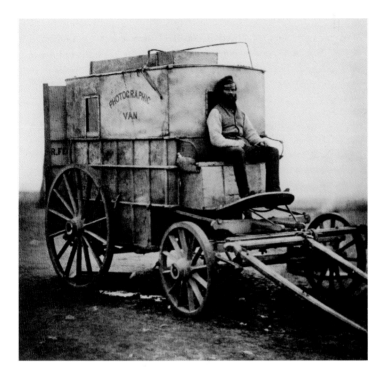

Roger Fenton's horse-drawn darkroom van, which he used for his Crimean expedition, had been tried out during a trip to Yorkshire in the autumn of 1854, during which time he photographed several of that county's magnificent abbeys. As a result of this practical experience, the van was modified before he set sail for the Black Sea. While in the Crimea, Fenton's assistant, Marcus Sparling, and 'William' the handyman slept underneath the van.

previously worked. The stock of glass plates was, I think 700, of three different sizes, fitted into grooved boxes, each of which contained about twenty-four plates; the boxes of glass were again packed in chests so as to ensure their security. Several chests of chemicals, a small still with stove, three or four printing frames, gutta-percha baths and dishes, and a few carpenters' tools, formed the principal part of the photographic baggage.

Fenton's photograph of Sparling 'on the box' – in the driving seat of the van – was converted into a remarkably faithful woodcut for use in the *Illustrated London News*.

I must not forget, however, what was to be the foundation of all my labours, the travelling dark-room. The carriage, which has already had an existence chequered with many adventures by field and flood, began its career, so far as the present historian knows, in the service of a wine merchant at Canterbury.

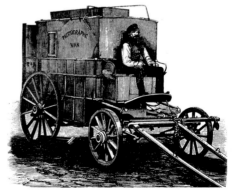

When it entered into the service of Art, a fresh top was made for it, so as to convert it into a dark-room; panes of yellow glass, with shutters, were fixed in the sides; a bed was constructed

13

for it, which folded up into a very small space under the bench at the upper end; round the top were cisterns for distilled and for ordinary water, and a shelf for books. On the sides were places for fixing the gutta-percha baths, glass dippers, knives, forks and spoons. The kettles and cups hung from the roof. On the floor, under the trough for receiving waste water, was a frame with holes in which were fixed the heavier bottles. This frame had at night to be lifted up and placed on the working bench with the cameras, to make room for the bed, the furniture of which was, during the day, contained in the box under the driving seat.

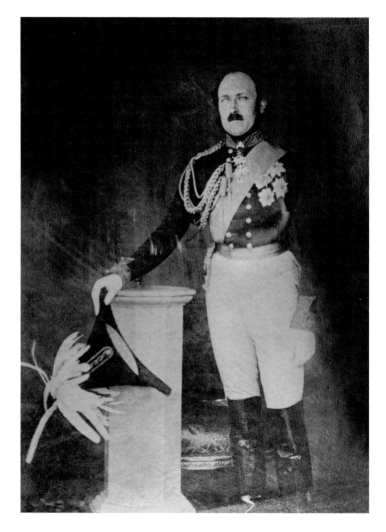

HRH Prince Albert, the Prince Consort, in the dress uniform of a Field Marshal, the highest ranking officer in the British Army – a rank bestowed on him at the time of his wedding to Queen Victoria in 1840. While many of those who have carried the rank were eminent serving soldiers, a substantial number never saw service, and wore the uniform only on ceremonial occasions. This portrait of him was taken by Roger Fenton at Buckingham Palace in May or June 1854, at a time when Albert's interest in photography was growing. He went on to promote photography widely, and became a keen amateur photographer himself, starting the Royal Photograph Collection at Windsor Castle.

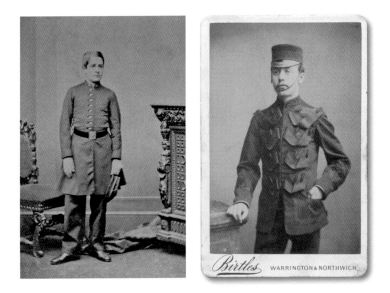

Far left: A studio portrait of an unidentified soldier, 1855–60.

Left: Guardsman in ornate patrol jacket, by Birtles of Warrington. The jacket style was in use between 1870 and 1888. The pink card on which this cabinet print is mounted is typical of the mid to late 1880s.

While Fenton has given us no idea of the total weight of his baggage, we do know from Francis Frith's account of his photographic journey up the Nile in Egypt at about the same time, that his equipment and materials in total weighed over seven hundred kilograms — two thirds of a ton. Fenton's baggage is unlikely to have weighed any less. By virtue of its sensitivity and

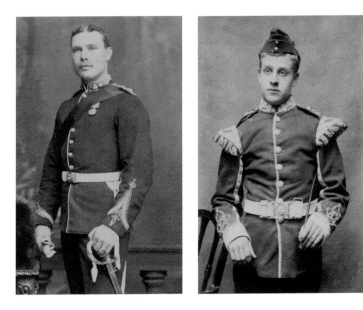

Far left: A young cavalry officer in the 1860s.

Left: A dragoon in dress uniform, c. 1875. His braiding has an elaborate crown motif woven into the silk, and on his belt buckle can be read 'Royal — Cavalry'. The missing word is unreadable.

Below: America produced some of the finest military photography in the nineteenth century, especially stereoscopic images. In this 1899 stereocard, entitled 'A Thousand Boys in Blue', the photographer has carefully positioned the camera to maximise the stereoscopic effect. It was taken at the beginning of the 1899–1902 war between America and Spain over the future of the Philippines. The US and Spain eventually signed the Treaty of Paris, in which America acquired Puerto Rico, Guam, and the Philippines. America would govern the Philippines from 1901 until its independence was granted in 1946.

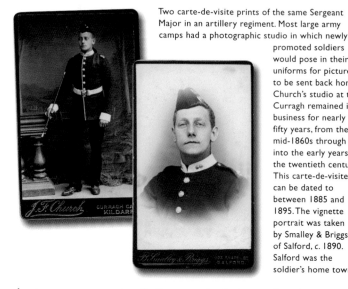

Two carte-de-visite prints of the same Sergeant Major in an artillery regiment. Most large army camps had a photographic studio in which newly promoted soldiers would pose in their uniforms for pictures to be sent back home. Church's studio at the Curragh remained in business for nearly fifty years, from the mid-1860s through into the early years of the twentieth century. This carte-de-visite can be dated to between 1885 and 1895. The vignette portrait was taken by Smalley & Briggs of Salford, c. 1890. Salford was the soldier's home town.

short exposures, wet collodion remained the preferred process of photographers into the 1870s, despite the availability of easier to manipulate, but slower, processes since the mid-1860s.

The wet collodion process was used in photographic studios across the country to take millions of studio portraits, and having a studio near a large number of soldiers or sailors offered a ready customer base. So popular was the practice of having one's photograph taken in a new uniform, or upon promotion, that most of the large military camps in Britain either had their

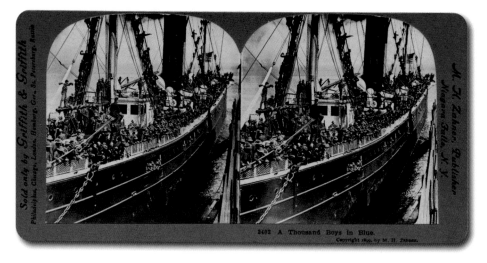

3402 A Thousand Boys In Blue.
Copyright 1899, by M. H. Zahner.

own photographic studios – an early commercial franchise which photographers were only too happy to take up – or encouraged photographers to set up nearby.

Indeed, soldiers from as early as the 1850s had themselves photographed frequently. Some of the most successful early studios were to be found in Aldershot, Woolwich, and the Curragh. In some places, competition was rife – there were, consistently, at least two studios in Wellington Street, Woolwich, in the 1870s through to the 1890s, catering for military as well as civilian sittings – Charles J. Fairlie had opened first at No. 69 in the 1860s, moving to No. 74 a

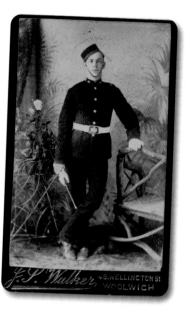

A soldier in an artillery regiment, taken on dry plate in the late 1880s by J. P. Walker. His studio at 48 Wellington Street operated from 1887 until 1918.

decade later. His competitor at No. 48 was Joseph Street (J. P.) Walker, but at various times during Fairlie's career, he had other competition at Nos. 5, 6, 17, 22, 63, 69, 74, 75, 76, 77–8, 82 and 101. Just how lucrative the military market must have been can be gauged by the fact that at one point

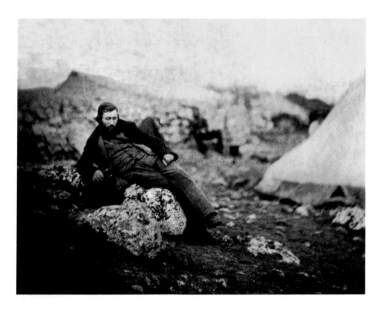

The work which Glasgow-born William Simpson (1823–99) produced during his months in the Crimea earned him the nickname 'Crimean Simpson' and marks him out as one of the pre-eminent war artists of his day. It is fitting that photography – which would in time largely usurp the role of the war artist sketching in the field – was used to capture him relaxing in camp. Perhaps surprisingly, Simpson's sketches often appeared in the *Illustrated London News* before engravings based on any of Fenton's photographs.

in the early 1860s there were five studios open in Wellington Street at the same time, and there were always five or six studios competing for the soldiers' business from 1876 through to the end of the century.

While prices varied up and down the country, usually no more than half a crown could buy a sitting and a dozen small card-mounted carte-de-visite prints in the 1860s, ready to be slipped into the albums of family and friends. For those with a bit more money, upmarket photographers like Henry Dixon, Camille Silvy and others offered a similar service but at a premium price.

In the 1850s and 1860s, the collodion positive, or ambrotype, tinted and gilded and set in a leather case, could cost half a guinea or more, whereas a daguerreotype portrait – produced on a silvered copper plate – could cost several times that amount from some of the leading London studios.

Whether in the studio or on location, the wet-collodion photographer had a lot of work to do before and after taking each picture. In the studio, assistants might do much of the preparatory work, but in the field the photographer often worked alone. Not so Fenton – he had Sparling to assist and he was a talented operative as well as a serving soldier. He would later become an accomplished teacher and writer, his 1856 book *The Theory and Practice of the Photographic Art* becoming one of the most successful instruction manuals of its day. In it, he gave a detailed account of each of the processes then in common usage.

The success of the wet-collodion process could be compromised at so many stages of the plate's production that cleanliness at every step was paramount. The photographer had first to thoroughly clean the sheet of glass, removing every trace of grease or fingerprints, and every speck of dust.

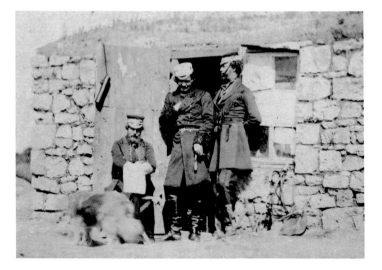

A group portrait of Sir Richard England's staff, taken in the Crimea by Roger Fenton. The temperature got so high during the day that his collodion boiled on the plate as he poured it. To avoid such catastrophes, he limited his photography to a few cooler hours, starting very early in the morning.

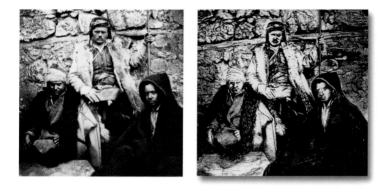

Left and right: Fenton's photograph of a group of Croats, taken in the early summer of 1855, and the line illustration based on it, which was published in the *Illustrated London News* a few weeks later.

If the glass had any blemishes – scratches or bubbles – it had to be immediately discarded. It also had to be perfectly flat, otherwise it might subsequently shatter when placed in the frame for printing. The use of a caustic potash wash was recommended to clean the surface.

Then the iodised collodion – a mixture of gun cotton dissolved in ether and alcohol combined usually with potassium or ammonium iodide – was poured into the centre of the plate, the glass then being carefully tilted in every direction to help the tacky mixture spread evenly.

Once coated, the plate was dipped in a bath of silver nitrate solution, which rendered it light sensitive and ready to be exposed, still wet, in the camera. Getting the strengths of the various solutions just right was never easy, as most photographers made their own collodion, and had different understandings of the chemical reactions involved. As a result, there was a lot of experimentation, and a confusing array of different recipes published in the emerging photographic press.

Left and right: Two other *Illustrated London News* illustrations based on Fenton's portraits – the French commander General Bosquet seated outside his tent in dress uniform, and General Sir James Simpson, the British commander.

With home-made chemistry, and without exposure meters to measure light levels, getting the exposure right was the next challenge. In the studio this was less of a problem, but on location light levels could vary enormously. In many of Britain's Victorian war zones – the Crimea, Africa and India amongst them – the light levels often exceeded anything encountered at home. Only experience gave the photographer a rough guide, and if they got it wrong, they either extended or cut short the development time. As early plates were only sensitive to blue light and could therefore be developed in a room illuminated through yellow glass, the photographer could at least watch the developing process as it progressed.

Development was in a solution of pyrogallic acid, and was followed by fixing in sodium thiosulphate – known to subsequent generations of photographers as 'hypo' as the Victorians referred to it as sodium hyposulphate.

The plate was then washed in distilled water and dried before being varnished to protect the delicate collodion surface. One of the recommended varnishes contained chloroform, so working with that in a confined space was not recommended! The varnish took up to two days to dry completely, and as it was drying, the highly adhesive surface was a magnet for dust if not contained in a dust-free environment. That photographers in makeshift darkrooms in war zones or deserts managed to avoid their negatives becoming peppered with dust specks is remarkable.

Six or eight negatives was considered a good day's output, and with all that work involved, it is easy to understand why!

Of course, for the war photographer, getting his pictures in print was a very different matter to today. Until the closing years of the nineteenth century magazines and newspapers were incapable of reproducing the subtle tones of a photograph. So their pictures had to be converted into line illustrations by artists. In the case of Roger Fenton, he would make a single

HMS *Orlando*, launched in 1858. At 336 feet, she and her sister HMS *Mersey* were the Navy's longest wooden ships. Photographer George Washington Wilson used a small stereo camera fitted with a large-aperture lens, allowing exposure times of a fraction of a second even with wet collodion negatives.

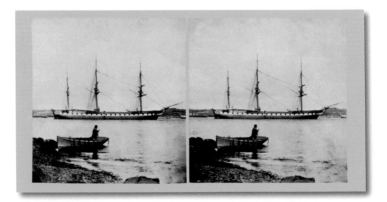

print from his glass plate negatives and ship that back home to the *Illustrated London News*. It would take days if not weeks to get the picture back to England, and then hours of work by an engraver to make the line block which would appear in the magazine. Of course such periodicals were not the norm. Daily newspapers often carried no illustrations at all, just page after page of tightly packed text. Photography remained on the periphery of journalism almost until the nineteenth century drew to a close.

As far as actually taking a picture was concerned, things got progressively easier for the photographer as the second half of the century progressed.

Initially slower than their wet-collodion predecessors, dry plates gained in both sensitivity and reliability, encouraging professionals, for the first time, to entrust the manufacture of their negative materials to someone else, and freeing them to concentrate on the immediate task of taking pictures. Faster plates brought shorter exposures and a greater immediacy to war photography. By the late 1870s exposures of a fraction of a second on dry plates enabled action to be 'frozen', and more portable cameras, using smaller plates and bigger lenses, proved to be the ideal combination. Of course, in the context of late Victorian photography, 'small' does not mean the same as it does today: small Victorian cameras were still very much larger and heavier than even the largest of today's instruments. And as they all took glass plate negatives, the bulk of equipment and materials which photographers had to carry with them to conflicts such as those in Egypt, Sudan, Afghanistan, South Africa, India and elsewhere still posed considerable logistical challenges.

Over those years and those campaigns, the level of realism in photographs increased. While there were still many posed groups of officers and men, the quest for images which told the real stories of war was gathering momentum as the photographic process became more adaptable.

While Fenton's Crimean pictures clearly present a sanitised view of the war – an imperative imposed by his publisher's need to recoup the considerable financial outlay for the trip – others were not so restrained. Constantinople-based James Robertson photographed the shattered remains of the Russian forts during the Crimea, Felice Beato photographed the execution of rebels in India in 1858, and some amateur photographers, in their fascination with the potential of the evolving medium, showed singular

Reynolds's Newspaper carried reports on the Indian Mutiny in its edition of 20 June 1858. Like all newspapers of the day, the report comprised pages of solid text, without illustration.

21

'War Correspondents watching a fight', photographed by T. J. Britten, and included in Arthur H. Scaife's book *The War to Date* (March 1, 1900) published by T. Fisher Unwin of Paternoster Square, London.

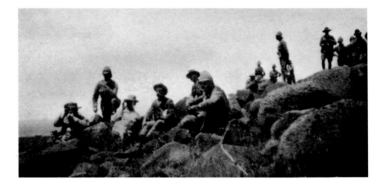

disregard for any sense of decency or humanity in seeking to get more and more realistic pictures.

One account in *The Times* of 21 January 1886 reported that the British Provost Marshal in Burma, Colonel W. W. Hooper, 'who is an ardent amateur photographer', wanted to get photographs of the execution by firing squad of Burmese bandits,

> … at the precise moment when they are struck by the bullets. To secure this result, after the orders 'Ready', 'Present' have been given to the firing party, the Provost Marshal fixes his camera on the prisoners, who at times are kept waiting for some minutes in that position. The officer commanding the firing party is then directed by the Provost Marshal to give the order to fire at the precise moment when he exposes his plate. So far no satisfactory negatives have been obtained, and the experiments are likely to be continued.

This advertisement for Tabloid developer, 1902, attests to its popularity in South Africa, and also states that '"Tabloid" is an arbitrarily coined word' and a registered brand name of Burroughs Wellcome Ltd – a far cry from today's rather derogatory meaning!

The following are a few of the many reports received from photographers abroad :—

South Africa :—"'Tabloid' Photographic Chemicals formed a very important part in the outfit which I took with me to the war in South Africa, and it passes my comprehension altogether to think what I should have done without them. Although they were subjected to the severe trials of the South African climate, they kept in perfect condition all the time." (H. C. Shelley, Special War Correspondent to the *Westminster Gazette* and *The King*). China Station :—"I have been using your 'Tabloid' Developers for the last twelve months both for films and plates, and they have given me the utmost satisfaction. I have used them throughout a rainy season in the Philippines, with the thermometer close on 100° F. in my cabin. On board ship and in the field they are the only developers admissible." India :—"After carrying these 'Tabloid' Chemicals all over Burma, Madras, and the Indian frontier, I used the last yesterday, and got an equally good result as with the first." Etc., etc.

Although Hooper was reprimanded for his crassness, the emerging realisation that the photograph had the potential to shock could not be stopped, and the sensitivities of the mid-Victorian era seem far in the past when looking at the brutally direct imagery of the Boer Wars, or the 1904–5 war between the Russians and the Japanese.

Photography, of course, was by then an altogether more sophisticated imaging system than had been the case in the American Civil War – and although these wars themselves were probably no more or less bloody, many Boer War photographs have a brutal immediacy which the longer exposures required forty years earlier had rendered impossible.

The horror of the trenches filled with British dead at Spion Kop is beyond question. The images of British soldiers returning to base at Ladysmith, or the captured Boer prisoners, are all well-known pictures, but are they representative?

What is interesting about the Boer War is that it was the last war – until Vietnam – in which there was relatively little censorship and control of the photographers travelling with the troops. While there was vetting of the dispatches from the writers in the war correspondents' pool, photographers seem to have been subject to few restrictions. Indeed, there is evidence that some photographers actually persuaded the authorities to ship their plates back to Britain unprocessed, as it had been suggested that the quality of the South African water supply was unsuitable for photographic use – an interesting idea, as leaflets for Tabloid developer tablets at the time claimed that these chemicals had been tested under battle conditions by leading news photographers.

If there were so few restrictions, why did photographers not recognise the historical need for accuracy once all the jingoism of the campaign had been

Photographed in 1904 off Port Arthur at the height of the Russian–Japanese War, the Russian cruiser *Peresviet* fires a broadside. At the Battle of Tsushima in May 1905 she suffered damage and, along with five other Russian warships, was captured by the Japanese. The cruiser *Aurora*, which would later play such a significant role in the Russian Revolution, escaped capture and fled to the Philippines, only to be interned by the American authorities in Manila, where she sat out the rest of that war.

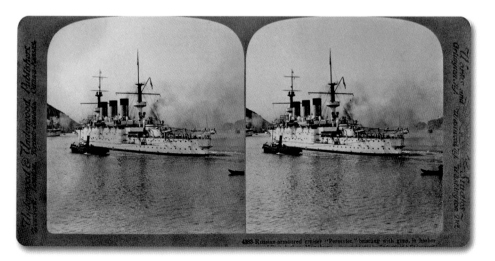

Right: Bringing the
meat on board –
one of many
postcards looking at
all aspects of naval
life in the Edwardian
years.

Below right: British
warships moored
at Calcutta in the
mid-1860s, from a
photograph taken
by Samuel Bourne,
a bank clerk from
Nottingham who
became one of
India's most
renowned Victorian
photographers.
Bourne & Shepherd,
the studio he helped
establish, was the
studio of choice for
the British Raj, and
for India's many
princes. Now under
Indian ownership,
Bourne & Shepherd
is still in operation
today. At the time
he took this
photograph, the
Royal Navy's fleet
still largely
depended on sail –
both because the
steam engines were
often unreliable, and
because steamships
became slow and
difficult to navigate
if they carried
sufficient coal for
their long voyages.
Though coaling
stations were
established all the
way around Africa
to support the
steamers, the belief
in (and reliance on)
sail endured until
the closing years of
Victoria's reign.

relegated to the margins? Loyalty towards King and country perhaps – that Edwardian legacy of the Victorian era that it was one's duty not to do or say anything which might undermine the official line? It was a golden opportunity lost for ever. Britain's next major war would be the Great War against Germany, with the military and governmental censorship machine in full working order.

Even Horace Nicholls – who would become a War Ministry official photographer during the

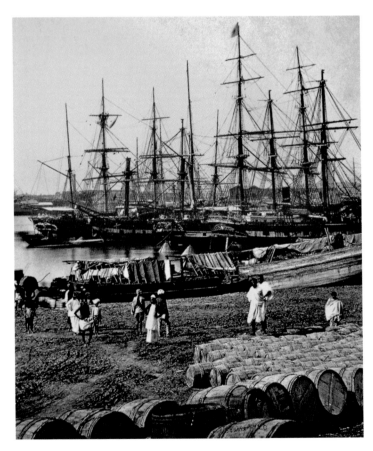

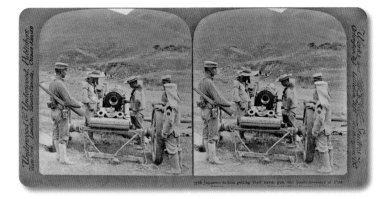

A Japanese naval gun being fired in the hills above Port Arthur (Lushun) during the war between Japan and Russia.

Great War and the author of some powerful visual statements – made poor use of the opportunity to use photography to create what might have become war's first comprehensive visual document. His own words showed that he understood too little the essential difference between photography and photojournalism: 'I have made it my great aim throughout the campaign to produce a series of large photographs which would appeal to the artistic sense of the most fastidious.'

In doing so he allowed the compositional constructions of his pictures to obscure the need to generate images with an honesty and immediacy which would have placed their authenticity as definitive documents beyond question. Arguably, that opportunity would not present itself again for nearly seventy years – not until the likes of David Douglas Duncan, Philip Jones Griffiths, Don McCullin and Larry Burrows brought honesty and compassion together in their explicit account of the war in Vietnam.

The Second Boer War marked the start of the era of the photographically illustrated magazine – an era which very quickly became competitive. Several new titles vied with each other for the best photographs, the most up-to-date stories, and the most realistic and representative accounts of the conflict. *The Sphere*, the *King, With the Flag to Pretoria,* and *Black and White Budget* all started publication around the same time, in direct competition with the established *Illustrated London News*.

Early on in the new century, one magazine, the *King*, inferred in its advertising that not all its competitors were being as honest in their photographic coverage as they should be:

> It is wrong to deceive people by publishing as actual war pictures, imaginative war pictures done in London. It is wrong to deceive people by 'faking' up photographs in London, and making people think such photographs were taken in the seat of the war. It is wrong to deceive people

by publishing anything that is not what it pretends to be! The *King* is the only illustrated paper in London that consistently attempts to illustrate all news events by means of photographs in preference to drawings, simply because photographs show more actuality than drawings. It is the only paper which illustrates the actual life and operations of our troops at the front by means of photographs taken at the front.

The inference was clearly made – that the camera does not lie! The following century would prove beyond question that such an assertion was ill-founded.

Although on a smaller scale, photographers did have the opportunity to record a war fairly unhindered by governmental interference in the short but brutal encounter between the Japanese and the Russians in and around Port Arthur.

The giant clouds of smoke billowing from the Russian battleships shelling the coastline, the casual expressions as soldiers tumble the bodies of their enemies into a mass grave, all these are inescapable images of the horror of a twentieth-century war.

The first photographs started to appear on the front pages of newspapers at about the same time. The *Daily Mirror* was the pioneer in this respect, and by 1908, even provincial and local newspapers were experimenting with half-tone reproductions of photographs, albeit alongside the more traditional line illustrations.

Meal time at a camp of the Highland Light Infantry, *c.* 1905. Cooking pots cover the grass in front of the tent with the soldiers dressed for the camera in their brightly coloured uniforms.

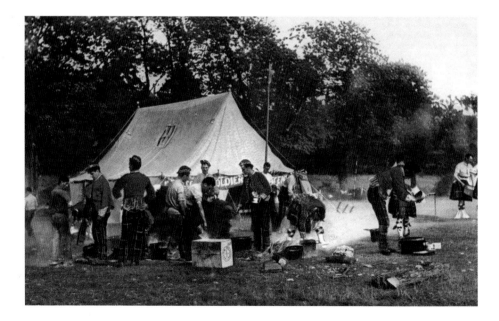

The Argyll and Sutherland Highlanders on manoeuvres at Avington Park near Winchester in Hampshire, photographed for Max Ettlinger's series of postcards in 1904 or 1905.

Between the beginning of the century and the outbreak of the First World War, the role of the photograph as a news document changed considerably. Of primary importance was the change from the news photograph's function as a commercial commodity, to an illustrative adjunct to the news story. In other words, the news photograph went from being

The assembly shop for light field guns at Armstrong's Elswick Works on Tyneside, c. 1905. This massive factory produced a wide range of armaments from relatively small guns to the huge weapons used on Dreadnoughts.

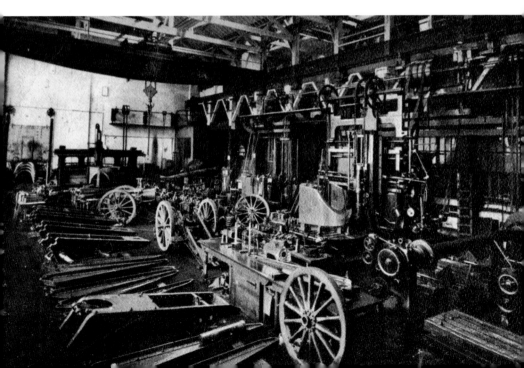

Britain's presence in India during the Edwardian era was massive, with several thousand troops and their families there at any given time. Even so, the vastness of the Indian sub-continent meant that the troops were thinly spread. This 1905 postcard, published in Calcutta and printed in Germany, shows troops on Kailana Neck near Chakrata, 7,000 feet above sea level. They were there to police one of the passes leading into Tibet. The area is today used to train some of India's special forces.

something which was sought out and bought by the interested members of the community, to being something which was commissioned and published on the reader's behalf by the daily newspaper. Thus the viewer went from active seeker of photography to passive recipient.

In a way, that change brought with it a change in attitude towards photography – and one which still causes problems today. The news photograph moved from being something which was only acquired after a definite considered decision to buy – in the illustrated book, the set of stereocards or whatever other form of publication, and long after it had ceased to be news – to a situation whereby no active decision whatsoever was required by the individual. That pivotal change in the process of acquisition brought with it the first evidence of control and censorship – an imposed censorship on what we ought or ought not to find when we open our newspapers, magazines or books. Editors became the arbiters of taste, rather than the reader or viewer. They made the ultimate decisions and selections about what the reader might accept at the breakfast table. The argument over the rights and wrongs of that still rages today.

The new century also saw the rise of the picture postcard, and with several postal deliveries and collections daily, it quickly became the most popular means of communication. Its popularity drove a near-insatiable

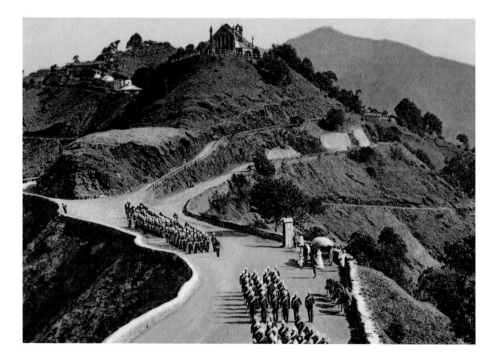

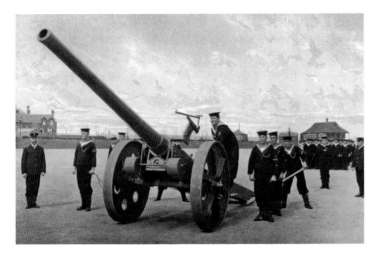

'Navy Gun Practice', an obviously posed study published as one of Max Ettlinger's *Life in the Navy* series of postcards around 1905.

demand for new cards, and with patriotic fervour widespread, military subjects enjoyed huge popularity. Scenes from Empire were commonplace, and specially commissioned series of cards depicting 'Life in Our Army' and 'Life in our Navy' enjoyed huge sales.

Also from Ettlinger's 'Royal' series the 14th King's Hussars in review order. Most of the cards in the series are credited to a photographer by the name of Knight.

Top: Here we see staff officers of the Grenadier Guards, with Colonel Lloyd in the foreground. Lloyd had led his Grenadiers during the battle of Biddulphsberg in May 1900 during the Boer War.

Centre: Cavalry under canvas just outside the huge Bulford Camp on Salisbury Plain, c. 1904. There has been a strong military presence on the plain for well over a century.

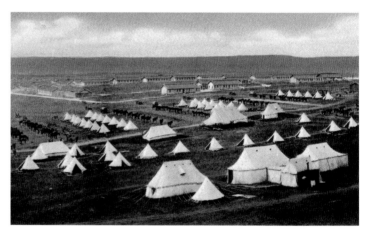

Bottom: King Edward VII reviews his fleet at Spithead from the deck of the Royal Yacht *Victoria and Albert* in 1902. This stereoscopic view was photographed over the main 13.5-inch guns of the flagship HMS *Royal Sovereign*. The 14,200-ton ship was completed at Portsmouth Dockyard in 1891 and commissioned in 1892, the first of a class of seven ships distinguished by the fact that their twin funnels were mounted side by side. Launched by Queen Victoria, the battleships were the most powerful in the British Navy until the advent of the Dreadnoughts in 1904.

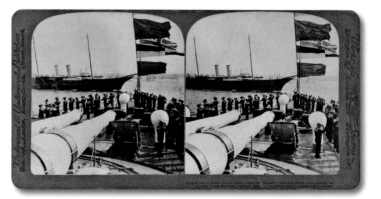

Given what would happen in 1914, there is a certain irony in the fact that the majority of the best printed cards of Britain's growing military might were printed not in Britain, but in Saxony and Bavaria in the heart of Germany. With the outbreak of the Great War, publishers who had proudly stated 'Printed at our Works in Essen' – or any of the other German cities where high-quality colour printing could be obtained – quickly blocked out such claims of their cards lest they might seem unpatriotic!

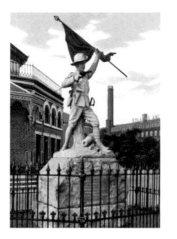

Top: The Boer War Memorial in Mesnes Park in Wigan, Lancashire, was paid for through a public subscription. It was unveiled in 1903, and stood outside the park pavilion until the bronze figure was removed for restoration in the 1970s. It was subsequently misplaced and never returned. Wigan sent many of its men to South Africa, and one of the terraces at the town's original rugby league ground, Central Park, was thereafter referred to as the Spion Kop end.

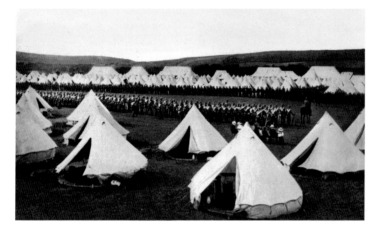

Middle: Soldiers returning from South Africa parade at Shorncliffe Camp on St Martin's Plain, Kent. The camp was the site of the Shorncliffe Redoubt, used to train infantry from the end of the eighteenth century.

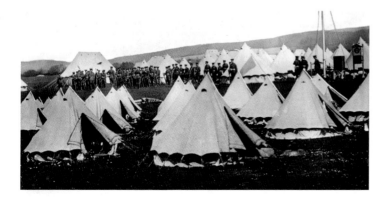

Bottom: A less formal view of life in Shorncliffe Camp, from the same period.

THE FIRST WAR PHOTOGRAPHERS

IN ISSUE 15 of the *Journal of the Photographic Society*, published on 21 March 1854, a correspondent signing himself only as 'Z' initiated a discussion on the value of photography in time of war:

> It is said that the military authorities intend sending a Photographer with the present expedition to the seat of war. If such should be the case, it would be a matter of congratulation to all Photographers to see their Art applied

to a new and very important practical purpose. It is highly satisfactory to find that the authorities are gradually becoming alive to the great uses to which photography may be turned; having once employed it, they will soon find that the results will even exceed their expectations.

He continued:

Many a voluminous despatch from the seat of war to the Government, might be saved by a faithful photographic representation of what is to be described; foreign ports, fortresses, lines of coast, disposition of fleets, battle-fields, &c., may be depicted in a few minutes, and observations of these objects may be quietly made from their photographic representation (especially if taken for the stereoscope) at a time when perhaps the only opportunity of seeing the objects themselves may have long passed away.

Just a month later, the journal reported that the Navy had indeed been experimenting with photography for just such purposes, and had sent a photographer to the Baltic on board HMS *Hecla*, accompanying Captain Scott. Scott was one of a number of naval captains and commanders on board the vessel, surveying the Baltic between 4 February and 18 March 1854 under the command of Master Commander Peter Wellington.

The report reads:

Many of our readers may have read in the daily papers that some experiments have been made on board one of the vessels of the Baltic fleet. The exact history of these, the products of which were exhibited at the last meeting of the Photographic Society, is as follows:– Capt. Scott, one of the Council of the Society, was accompanied to the Sound on board the *Hecla* by Mr. Elliott, who under Capt. Scott's directions, took a number of views of the coast, on collodion, with a double lens, while the vessel was moving at the rate of 10 knots per hour. Although taken under most adverse circumstances, on board a crowded vessel, where no arrangements had been made to facilitate the operations, these instantaneous pictures were exceedingly satisfactory, and sufficient to prove clearly the great service which the art is capable of rendering.

Elliott's pictures, reportedly, showed the fortress of Kronborg ('Kronberg' in the account) at Elsinore in Denmark. At the same meeting, and alongside Elliott's images, Roger Fenton's pictures of the fleet at Spithead were also exhibited, both sets of photographs exciting very positive reactions from the members present.

Opposte page:
The paddle steamer in the middle of Roger Fenton's photograph of a trio of steamships tied up at the Cattle Pier in Cossack Bay, Balaclava, may well be HMS *Hecla*, the vessel used as Elliott's camera platform in the Baltic. It was later also used to ferry several photographers, including Roger Fenton, to the seat of the war. Certainly the relative positions of paddle boxes and smoke stack match the drawings preserved by the engine-makers, Scott of Greenock. According to Fenton's letters, three steamers, including *Hecla*, entered the harbour together on 8 March 1855.

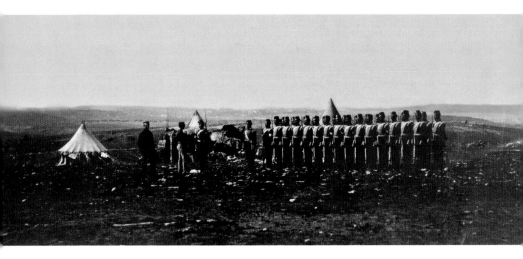

In the years before instantaneous photography was possible – early cameras had only a lens cap in place of a shutter – the medium was best suited to static subjects like strictly posed groups, typified by the view of the Light Company of the 38th, above, or Fenton's 'Cottages at Balaclava', below right.

Fenton was the Honorary Secretary of the Photographic Society, which he had helped to found in the previous year. Like Captain Scott, he sat on the Society's Council, so the success of Scott and Elliott's experiments would have been known to him before the meeting, and undoubtedly would have been of significant interest.

The pictures must, indeed, have been 'taken under most adverse circumstances', for HMS *Hecla*, the third Royal Navy ship to bear that name,

was a tiny 6-gun paddle-steamer sloop of 816 grt. Built in London in 1839, she and her sister ship HMS *Hecate* had then been taken to the Clyde under sail, where her steam engines were fitted by Scott of Greenock. The combination of a small boat and large 25-foot diameter paddle wheels cannot have resulted in a stable camera platform.

As the story of early war photography unfolds, the vessel will be seen to have played a pivotal role. And the *Hecla* also has an important place in the history of the Crimean War, for it was one of her mates (later known as midshipmen), twenty-year-old Charles Lucas, whose bravery under attack by the Russian fleet earned him the first ever Victoria Cross.

Just a few days after the report in the *Journal of the Photographic Society* the influential periodical *The Art Journal* picked up the story and expanded upon it. Elliott's pictures of the fortress at Kronborg, taken in Wingo Sound, were, according to the reporter, 'so correctly delineated, that we heard an engineer officer declare he could determine the bearing of every gun, and correctly lay down a plan of attack from the photographs.'

The Art Journal also informed its readers of the other plans which were afoot to introduce photography as a tool of war:

> It having been represented that much aid might be derived from photography in the engineering operations connected with the war in the East, the government have appointed an engineer officer, with two sappers and miners under him, to take charge of this department.

The journal, however, predicted that they would fail, 'from the simple reason, that they are unacquainted with the art.' The fact that they had received minimal training was also cited.

The officer was Captain John Hackett, and the two assistants, from the Woolwich-based Royal Sappers and Miners, were Lance-Corporal John Hammond, and Corporal John Pendered. What the reporter did not know was that they would be accompanied by a professional photographer, Richard Nicklin, employed by Dickinson Brothers who had recently opened a studio on New Bond Street. Nicklin's contract, at six shillings a day plus rations, was agreed on 29 May 1854.

Nicklin, Hammond and Pendered embarked for Balaclava on board HMS *Hecla* – by then commanded by Captain William Hutcheson Hall – with several crates of equipment and chemicals on 11 June 1854, but whether or not their work would have had any lasting value we will never know. They were all lost when the ship on which they were about to travel home, the *Rip van Winkle*, went down in the great storm which hit Balaclava in November 1854 and which cost the British countless lives and dozens of ships. As the war artist William Simpson later commented:

This woodcut of the hurricane and storm at Balaclava in November 1854 appeared in the *Illustrated London News* (see William Howard Russell's report of the storm, pages 45–6).

Whichever way you looked, you saw paddle-boxes, bows, sterns, many funnels and gangways of the various injured vessels, floating about in the water. None seems to have escaped. Lord Cardigan's yacht had her gunwale smashed in. It is difficult to conceive how so much mischief could have occurred in such a snug little harbour; but it would seem the ships were all lying so close together that they ground one another to pieces. Eight ships are reported to have sunk here, and about four thousand men were drowned. All the warm clothing for the army is lost, and a great quantity of provisions. The late storm has blown away tents, and the poor soldiers have just to do without them – and what miserable looking beings they are, covered with mud, dirt and rags. The rains too have left all the road a sea of mud about two feet deep, through which supplies must be drawn to the camps.

If Britain's first attempt at war photography came to nought, her second fared only a little better. Two ensigns, recorded only as Brandon and Dawson, were sent out in early 1855, and reportedly did bring back a body of work. Despite having had four weeks of training, their processing may not have been as careful as it should have been, and by 1869 the War Office reported that the pictures were in a deplorable condition. They are believed to have later been discarded.

The idea of using photography at war had first been suggested to the British authorities in an article in *The Practical Mechanics Journal* in January 1854, but rather than a novel suggestion, this was merely the first British recognition of an application to which other countries were already giving active consideration.

The earliest surviving images of an army on the move are probably those of General John Wool's cavalry regiment entering the Mexican town of Calle Real in 1847 during the Mexican–American War of 1846–8, the war which ended with Texas becoming part of the United States. The unique daguerreotypes (positive images on silvered copper plates) by an unknown photographer offer us the earliest sight yet discovered of troops in action. While not exactly warlike – the troops had to pause for the long daguerreotype exposure – they do represent a remarkable survival, albeit more in the established tradition of the staged tableau.

Also said to be from that conflict, a gruesome daguerreotype survives of a military surgeon carrying out an amputation, and holding the amputated limb towards the camera, while soldiers hold down the poor patient. Apart from these images, scenes of the war, like every other war before it, were captured in sketches, engravings and paintings by numerous war artists.

In British military engagements, a surgeon, Scots-born Dr John M'Cosh, was probably the first to carry a camera with him on active service. M'Cosh used the slow calotype process, which produced a paper negative, and the length of exposure required for that process, even in the bright light of India and Burma, also restricted him to posed pictures. M'Cosh's pictures, like most taken before 1860, are not 'of war', but rather simply 'at war', but taken with the amateur's eye for the picturesque.

A Romanian, Carol Pop(p) de Szathmari (1812–87) – also known as Carol Baptiste de Szathmari – was probably the first person to take

The earliest surviving photographs showing military activity were taken during the Mexican–American War. An unknown photographer took a remarkable series of sixth-plate daguerreotypes of American cavalry under the command of General John Wool entering the town of Calle Real, c. 1847. As the daguerreotype required a long exposure, the troops had to pause for the camera, resulting in some blurring of horses' heads.

Carl Baptiste de Szathmari's photographs of the war between Russia and Turkey are little known in the west, overshadowed by the more celebrated images by Fenton and others. Yet they illustrate aspects of the conflict not covered by anyone else. The only known collection of these images is in the Royal Collection at Windsor Castle. Although many of the photographs are posed groups, similar to Fenton's, some of the camp scenes are more animated and lively, with an almost spontaneous feel to them. Little is known of Szathmari's technique, except that he used the wet collodion process. These images are believed to date from the Russian invasion of Wallachia in the summer of 1854, nine months before Fenton's arrival in the Crimea, and show a considerable mastery of his craft. Their success is in sharp contrast to the failed British attempts to photograph the campaigns of 1854 which resulted in the death of Richard Nicklin and the loss of his images.

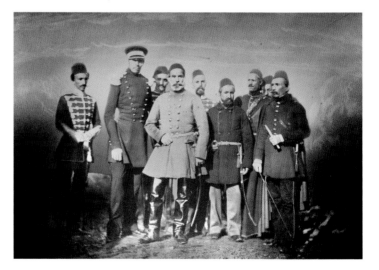

photographs in the war between Russia and Turkey, which later became known in Britain as the Crimean War. The Russian invasion of both Moldavia and Wallachia took place in the summer of 1854, and while Szathmari apparently photographed profusely in Wallachia, most of his work has subsequently been lost. What survives, however, is a fascinating collection of group portraits and staged location views of troops and equipment, some of which are published here for the first time.

From Ernest Lacan's account of one of Szathmari's battle scenes, published in *La Lumière* in 1855, it would seem that, for some of them, a deal of additional information was needed before the picture might be fully understood. He writes:

> To the right the great pontoon bridge below Silistria sketches its sombre form against the silvery waters of the river. Further in the distance, on the hilltops over which the wind chases and scatters the whitened clouds, can be seen some intersecting black lines which break off and then reunite in indistinct masses. These are the fighting armies. This is the battle.

Szathmari used wet-collodion glass plate negatives, and from the examples seen, managed to achieve relatively short exposures. Lacan's reference to 'indistinct masses' suggests that the action was too far away from the camera to be clearly discernible, rather than any shortcoming in the photographer's technique.

Szathmari's pictures aroused considerable interest, and were exhibited at the Exposition Universelle in Paris in May 1855. What is known of them comes from Lacan's 1856 publication, *Esquisses photographiques à propos de l'Exposition Universelle et de la Guerre d'Orient*, and from the few surviving examples.

The Russians abandoned their siege of Silistria before the end of June 1854, and over the following weeks completely withdrew their forces from Wallachia and Moldavia. This establishes a fairly narrow time frame within which to set Szathmari's pictures.

In 2001, a number of waxed paper negatives were discovered, which some researchers have suggested may have been taken by Welsh amateur photographer Charles Clifford in the late autumn of 1854. Although this attribution comes from information assembled some fifty years later, the case is quite compelling. One of the images, overleaf, shows a line of field guns with the ghostly image of a soldier standing in front, and a seated group to the left. The soldier's cap suggests he was French, and the early twentieth-century annotation accompanying the negatives is written in French. France officially entered the war in February 1854, and their troops were first deployed into the Turkish province of Bulgaria in May. They arrived on the

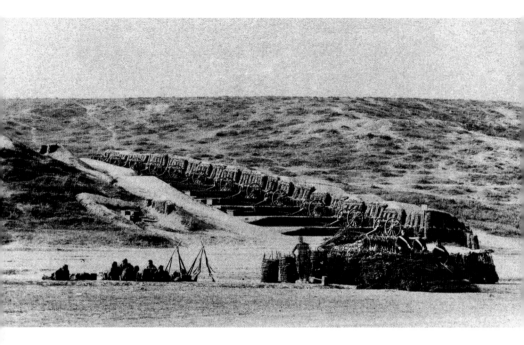

French lines, Crimea, probably late autumn 1854. A photograph taken on waxed paper, attributed to Charles Clifford. French and British forces arrived in the Crimea in mid-September 1854.

Crimean peninsula on 14 September, so unless the gun deployment pictured in this image is from Bulgaria rather than the Crimea, it is unlikely to have been taken before then. There were several notable and successful French photographers operating in the war zone during 1855, and a significant number of their superb images survives, but so far none has been identified as being active there in 1854.

The long exposure required with waxed paper negatives was mainly suited to static subjects, but whoever authored these images, they are certainly amongst the earliest surviving photographs of the Crimean War and, if indeed they are by Charles Clifford, they would represent the earliest British images of the war, predating Fenton's celebrated oeuvre by more than six months.

Roger Fenton's expedition to the Crimea has often been portrayed as having been hastily arranged after the loss of Nicklin's party in mid-November, and the subsequent disquieting accounts from William Howard Russell, special correspondent of *The Times* who reported regularly from the Crimea, but it was clearly in an advanced state of planning well before then.

He had purchased the wine-merchant's van which would become his mobile darkroom in the summer of 1854 — within little more than three months of Queen Victoria's announcement to Parliament that 'Her Majesty

feels bound to afford active assistance to her ally the Sultan against unprovoked aggression.' A trip to Yorkshire photographing abbeys and castles in late summer and early autumn had put the van through its paces.

While academics have hypothesised about the timing of Fenton's commission, it remains unclear just who initiated the contact between the photographer and Manchester publishers Thomas Agnew and Sons, or, indeed, when that initial contact might have been made.

When Britain became involved in the conflict with Russia, there was a widely held belief that the allied forces would teach the Russians a quick and decisive lesson, which, of course, turned out to be far from the truth. Instead, Britain became embroiled in a prolonged struggle, thousands of miles from home, with poor communications and a very fragmented and unreliable supply line.

Is it possible that Fenton's mission to the Crimea had been intended to happen some months earlier? With the practicalities of the photographic van resolved and refined by the late autumn, might it have been anticipated that he would get there in time to see and photograph a quick victory? We may never know, but in any event, he did sail for the Black Sea from Blackwall Pier

Aftermath of battle, Crimea, early 1855, attributed to Charles Clifford. The battle-scarred landscape offers a scene more often associated with the Somme sixty years later. This unidentified eerie landscape is devoid of people, but bears all the scars of intense and devastating military activity.

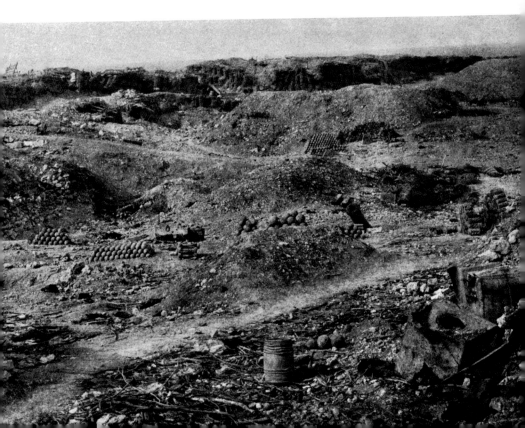

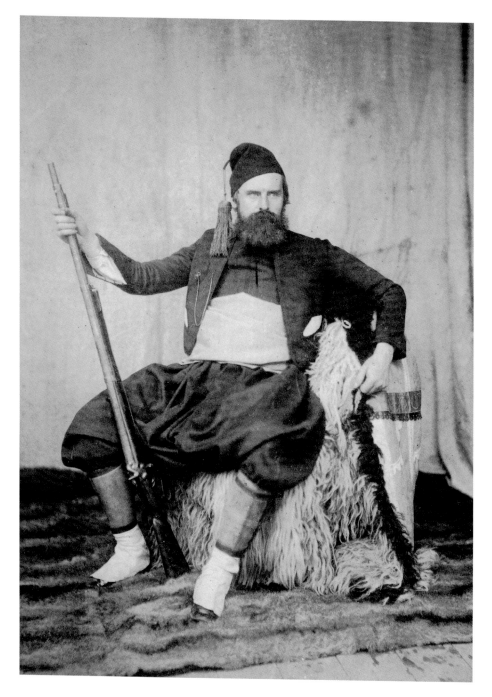

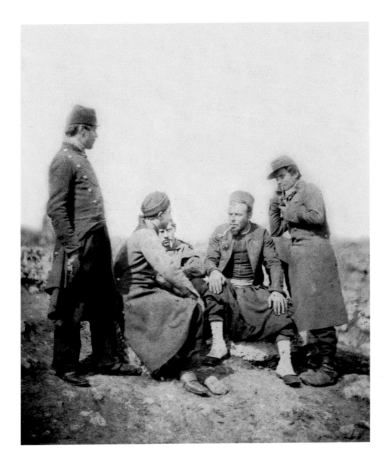

Roger Fenton's study of a group of French Zouaves enjoying a smoke near Balaclava, spring 1855. The exposure time Fenton used to take this may have been as little as half a second in the bright Crimean light, but still nothing like short enough to capture action, had he ever wished to do so. Even when taking such obviously posed portraits, the length of time taken to prepare his glass plate before exposure and process it afterwards made his photographic darkroom van a target on more than one occasion.

in London on 20 February 1855, on board HMS *Hecla*, arriving at Balaclava on 8 March.

He started work immediately he had disembarked from the ship, and produced a total of around 350 pictures – with slight variants on some of them where the camera has been moved slightly to improve a composition.

Fenton also wrote long and detailed letters to his wife and to William Agnew, his publisher, and there is a marked difference between the stories he told in words and pictures. He was, unashamedly, establishing two quite different contexts – the accurate and clinical account of the war from the point of view of an eyewitness with a pen, and the political and stage-managed 'official picture' created by the photographic businessman with his camera who knew what he had to do if his images were to sell. But then, he knew the technology he was using was incapable of recording action, and that to show the true horror might be considered disloyal.

Opposite:
Roger Fenton in a borrowed Zouave uniform, photographed while he was in the Crimea. He and Sparling appeared anonymously in several of his photographs, in a variety of dress.

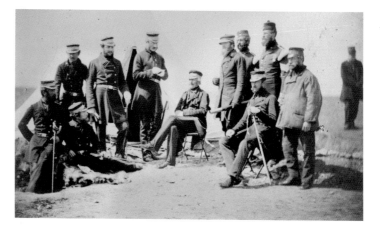

Left: Fenton captioned this group portrait 'Lieutenant-General J. Pennefather and Staff' but by the time it was taken, John Lysaght Pennefather was already a Major-General and Commander of the 1st Brigade, 2nd Division. He had been heavily involved in the Battles of Alma and Inkerman in October and November 1854.

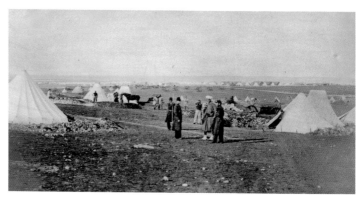

Centre: General Bosquet's quarters. Pierre François Joseph Bosquet led the French attack at the Battle of Alma, and he and his troops played a pivotal role in the victory at Inkerman. Fenton made several portraits of him, some seated outside his simple tent.

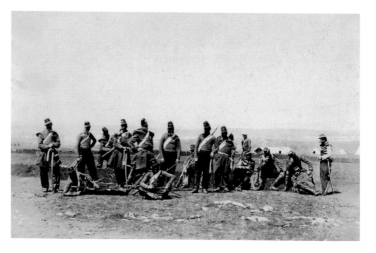

Bottom: The Chasseurs d'Afrique were a light cavalry unit in the French Army, first raised in the 1830s. Their name means, literally, 'African Hunters', and they were largely made up of men from France's African colonies doing their national service. They rode in support of the Light Brigade as they charged into the Valley of Death.

THE CRIMEA

SPREAD ACROSS the plains of Sevastopol, as far as the eye could see, were white-painted wooden huts, row upon row of tents, and masses of men and equipment. This was the scene which greeted Roger Fenton in March 1855 as he began his historic mission to photograph the people and the places at what the mid-nineteenth century media described as 'the seat of the war in the east'.

The weather was fine, the air clear, and the camera could see for miles. The photographs show scenes of order, of reasonable accommodation for the troops, and of adequate supplies of military equipment – in short, they show a war apparently being led and managed effectively, thousands of miles from home.

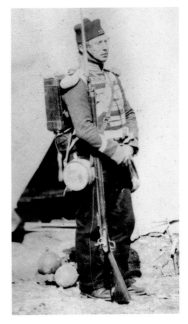

Private soldier in full marching order, 1855.

This was a marked improvement from a few months previously, as readers of *The Times* had become only too well aware through the highly charged accounts which had been dispatched back from the newspaper's Special Correspondent, William Howard Russell. Those had told of appalling conditions, extreme hardships, disease and death on a scale the British public could hardly grasp.

Of the conditions in the trenches at the time of the November 1854 storm, Russell had written:

It is now pouring rain—the skies are black as ink—the wind is howling over the staggering tents—the trenches are turned into dykes—in the tents the water is sometimes a foot deep—our men have not either warm or waterproof clothing—they are out for twelve hours at a time in the trenches—they are plunged into the inevitable miseries of a winter campaign—and not a soul seems to care for their comfort or even for their lives. These are hard truths, but the people of England must hear them! They must know that the wretched beggar who wanders about the streets of

The camp of the 5th Dragoon Guards was one of many spread across the plain near Sevastopol. Fenton was obviously impressed by the scale of the British and French presence. In one remarkable eleven-picture sequence, he produced an almost 360° view of the plateau.

London in the rain leads the life of a prince compared with the British soldiers who are fighting out here for their country.

It takes little imagination to consider the impact such graphic detail must have had on the readership of *The Times*; the effect was enormous. For the first time the spectre of defeat – the possibility of which had perhaps not previously even been considered – was apparent even to the most obstinate in England.

Colonel Henry Smyth, commanding the 68th Regiment of Foot, wrote in his diary, 'Such a scene of confusion. Caps flying away and in the middle of the storm the big drum of some other regiment came rolling through our lines. It was impossible to stop it.' Smyth, who had purchased the command of the 68th – as was the norm at the time – just a year earlier, must have

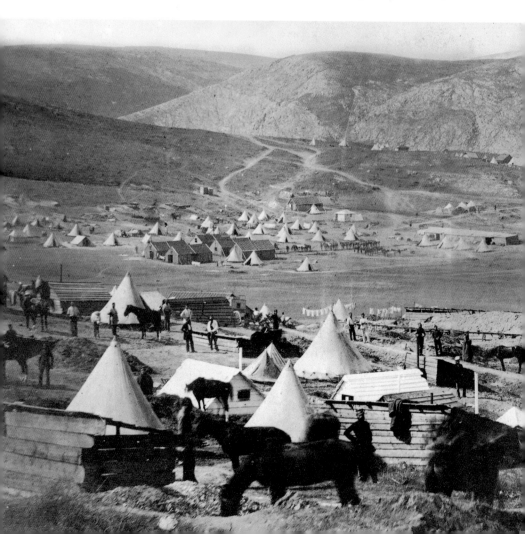

wondered what he had let himself in for. Roger Fenton arrived in Balaclava harbour just over three months later, on 8 March 1855. Had conditions improved so dramatically in such a short space of time? The pictures apparently said so, but Fenton's letters home told a different story, as described later in this chapter.

The Crimean War came about as a result of several growing tensions. Initially there was a row between Russia and France over control of some of the holy sites in Palestine in 1852. In the following year a growing fear that Russia harboured a desire to increase its own authority by dismantling the Ottoman Empire, led to Britain, Austria and eventually France putting on a show of unity and strength, in the hope that this would dissuade the Tsar from continuing his machinations against the Sultan.

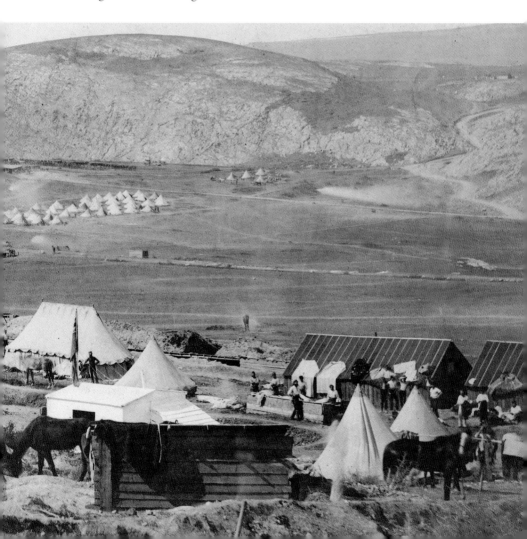

Tsar Nicholas had issued a demand to the Turks that, as head of the Orthodox Church, he alone should have the power and the right to protect all Christians living in the Ottoman Empire – a direct challenge to the Sultan's sovereign authority. When the Sultan refused to accept his terms, Russia responded by sending an army to occupy Wallachia and Moldavia, two Turkish-controlled principalities in present-day Romania.

The allies responded by sending a large combined fleet to Besika Bay near the Dardanelles. They anchored just outside the Straits, hoping not to provoke the Russians, but when they entered the Dardanelles they did give them cause – by breaching the 1841 Treaty of London which had declared that the straits should thereafter be closed to warships. Russia at last had a justification for war, but the Turks got their declaration in first. The Russian fleet attacked the Turkish navy, while Russian forces attacked the fortress at Silistria on the Danube.

The camp of the 71st Regiment of Foot looks a little more permanent than many of the others photographed by Fenton, with wooden barrack blocks at last providing the soldiers with decent shelter. The 71st Highlanders fought at the Siege of Sevastopol from September 1854, the majority living in tents through the appalling hardships of the winter. On the hillside in the distance can be seen many more rows of barracks. For this 1855 view, the soldiers would have been asked to stand still for the duration of the exposure.

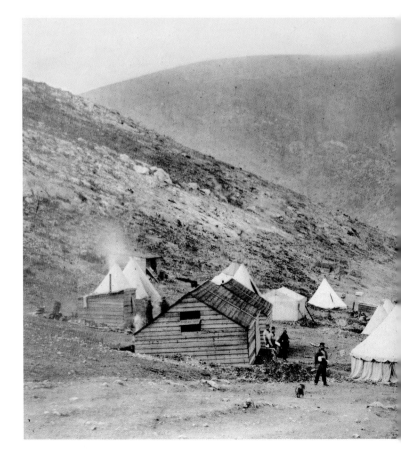

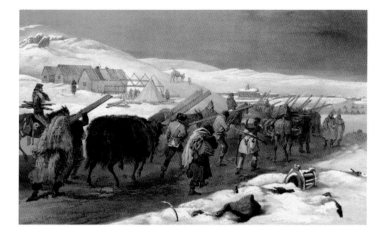

Alongside Fenton in the Crimea was war artist William Simpson. While his work could not capture the minute detail of the photograph, he was able to portray scenes and conditions which the relatively primitive and slow photographic processes of the day could not capture – such as troops on the move, and night action. Thus the work of artist and photographer are surprisingly complementary.

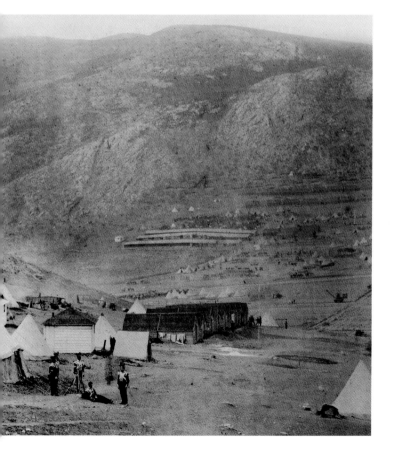

To get supplies to the front, the government accepted an offer from Sir Morton Peto, Britain's most successful railway builder, on behalf of his company Peto, Betts & Brassey to construct a light railway – at cost – from a point close to Balaclava harbour out to the main camp at Kadikoi and beyond on to the plateau near Sevastopol where the British supply depots were established. On 19 February 1855, *The Times* reported that the railway was complete beyond Kadikoi and that 'on Wednesday it will be, in all probability, used for the transport of a cargo of shot and shell out so far from Balaklava in the intervals of the workmen's labours.'

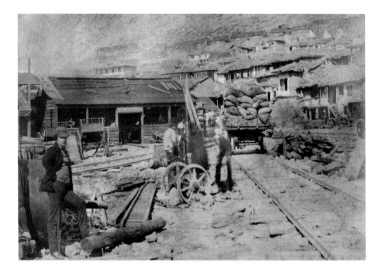

Crimean Braves, a print produced using the photogalvanographic process in June 1857, and published as part of the series *Photographic Art Treasures*. The soldiers, three privates from the Coldstream Guards, fought at Balaclava. The print is based on a photograph taken in 1856. By Joseph Cundall and Robert Howlett.

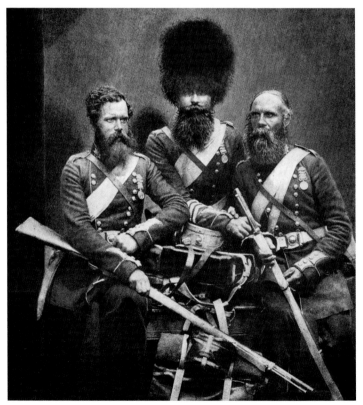

By March 1854, Britain and Austria had sent an ultimatum to the Tsar demanding that his troops be withdrawn from the Danube Principalities – although Austria, while armed, always intended to completely distance herself from any ensuing conflict. At least a year earlier, on the other hand, in March 1853, the British had already started preparing for what was seen as an inevitable war against Russia.

By the spring of 1854, British troops were encamped on the Gallipoli peninsula. They remained there for almost six months of relative inactivity, before sailing for Sevastopol in the autumn for what was expected to be a quick and successful attack on the port, then in the hands of the Russians.

Inadequate troop numbers, insufficient equipment, poor supplies, old-fashioned and out-dated leadership, and an inept and only partial blockade and siege, were just the beginning of the British woes. The anticipated two-week campaign to destroy the port and Russian fleet would eventually last a year.

When Roger Fenton arrived in the Crimea in March 1855, he was clearly fascinated by the campsites sprawling across the plain, and set out to record the scale of the British presence. From his camp scenes, we can clearly see that the facilities used to house and feed the troops, and to wage the war itself ranged from the nearly-permanent to the very temporary.

The Cavalry Camp at Kadikoi was the main British camp, and was quickly connected to Balaclava by a specially built horse-drawn railway. *The Times* reported on 19 February 1855 that the extreme hardships experienced by the troops over the winter seemed at an end, as provisons had arrived by the railway, diet had improved and scurvy was on the decline.

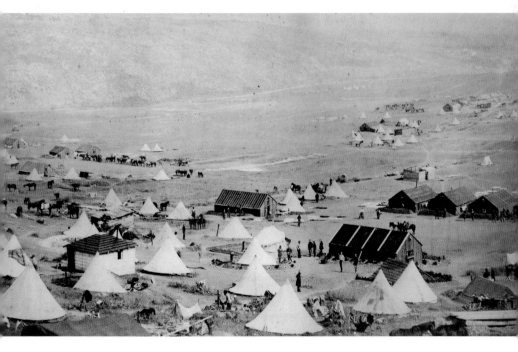

Soldiers of the 71st (Highland) Regiment of Foot, a regiment which could trace its origins back to Fraser's Highlanders and Mcleod's Highlanders in the eighteenth century. By the time Fenton photographed them in spring 1855, the 71st had been involved in the Siege of Sevastopol for nearly eight months – since its inception in September 1854. They would subsequently take part in the Kerch Expedition to Eastern Crimea from May to June 1855. After the Crimean campaign ended, they spent a period back in Britain before being deployed to India in 1858 where they served in several of the campaigns on the sub-continent. In 1881 the regiment was amalgamated with the 74th to form the legendary Highland Light Infantry. Despite the retention of 'Highland' in its name, the merged regiment recruited mainly from Glasgow and Central Scotland.

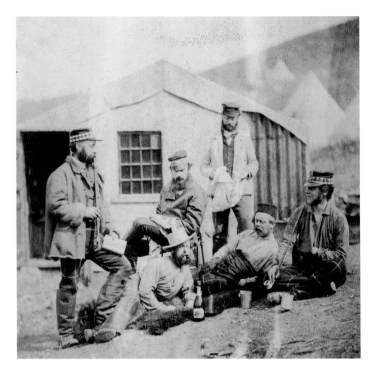

And if the troops had endured the winter of 1854–5 with only lightweight tents for protection, then Russell's claim that 'the wretched beggar who wanders about the streets of London in the rain leads the life of a prince compared with the British soldiers who are fighting out here for their country' does not seem, in any respect, to have been an exaggeration.

Fenton knew that battlefield photography was quite beyond the capability of the camera, so he wrote about the battles and other events which he could not photograph. Describing the attack on the Malakoff fort he remarked, 'We have just passed through what seems a hideous dream.' He wrote frankly about enormous loss of life through military blunders, lack of coordination between the British and French troops, and of the appalling death toll. After returning from an observation point overlooking the Redan, he wrote about some of the men he had dined with the previous evening:

> On my return I found poor Corbett's body in his tent, lying on the bed where twenty four hours before he had been lolling in the full enjoyment of life, with a hearty relish for fun. Wray was also lying dead in the next tent … out of five officers in the 88th, three were killed, one wounded and only one unhurt.

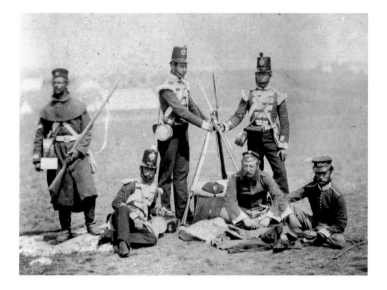

Fenton's group study *Infantry Piling Arms* could not capture the bright colours of the uniforms. Since before the Crimean War, in winter at least, the British soldiers' bright red tunics had been hidden beneath grey greatcoats. But, to ease access to their ammunition pouches, the 68th Durham Regiment of Foot had notoriously discarded their greatcoats during the Battle of Inkerman in November 1854, and fought in their red tunics. They made easy targets, and casualties were high, but it took more than thirty years before the troops were issued with less noticeable uniforms! The Durhams were later in action in the Sudan – the battle at Ginnis in 1885 in which the British and Egyptians fought the Mahdist Dervishes of Sudan; this was the last engagement at which any unit of the British Army wore scarlet uniforms.

For such losses to be suffered by the officers was largely unheard of. Time and time again in his letters, the 'all's well in the British trenches' approach is denied. Despite comments in his first letters that 'everything seems in much better order than '*The Times*' led me to expect' – perhaps the normal response

A group of Tartar labourers laying a roadway at the camp of the 14th Regiment near Sevastopol.

Captain Burnaby with a Nubian servant. The dashing Captain Burnaby was a Grenadier Guardsman, and appeared in at least two of Fenton's photographs. In October 1854 he was one of many to succumb to illness in the camps, and remained for several weeks in a hospital camp in charge of the sick before returning to his regimental post in the defence of Balaclava. During a highly successful military career, Edwyn Sherard Burnaby eventually rose to the rank of Major-General, and served as the Conservative Party Member of Parliament for Leicestershire North from 1880 until his death three years later at the age of fifty-two.

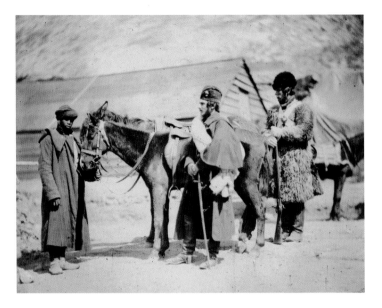

of a newcomer who has yet to get the feel of the place – later letters and reminiscences pulled few punches about the true horror of the experience.

If Fenton had hoped to see and photograph the end of the siege of Sevastopol, he was to be disappointed. Severe illness, which had affected so many of the troops, cut short his planned stay in the peninsula. Stricken by malaria, he set sail for home long before Sevastopol fell.

In his subsequent lecture to the Photographic Society in London, the tales of horror and death were tempered with moments of humour. Almost as soon as he had landed the photographic van on the harbour, and parked it alongside the railway which was then under construction, he had set about taking some test photographs. While developing his first negatives, he heard a knock on the van door followed by someone shouting that he should come out and take his photograph. When he declined, the voice replied 'What did you come for if you're not going to take pictures'. On several occasions the van, with himself working inside, was mistakenly identified as an ammunition wagon and became a target for the Russian guns. Both he and Sparling had to make their escape with all speed.

The story of any war is best told from the personal experience of every man who served in it, in whatever capacity. The personal accounts of Fenton, Russell and Simpson are complementary to the accounts of the officers and fighting men.

Fenton may not have been an active soldier, but his position in English society meant that he had many acquaintances and contacts who were already

active in the Crimea when he arrived. He used them, sometimes ruthlessly, to get him to the heart of the action – sometimes perhaps closer than he had intended!

There was also a family member in the British contingent – his brother-in-law Edmund Maynard, a Captain in the 88th Regiment, the Connaught Rangers – so his account of some of his experiences had a distinctly personal resonance. Of particular personal interest – and clearly leaving its mark on him thereafter – was the especially shocking attack on the Quarries on 5 June 1855. As he told his fellow members of the Photographic Society:

> At the end of May, I obtained leave to join the Kersch expedition, but returned to the camp in time to witness the attack on the Mamelon [Fort] by the French, and the Quarries by our own troops. On the day of the battle – having taken the portrait of General Pelissier, as already mentioned, at a very early hour, and the group of three commanders-in-chief in council – I

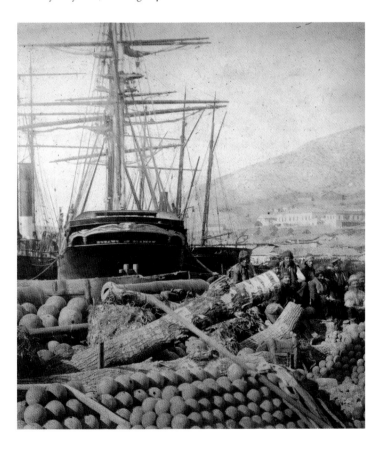

When the *Hecla* arrived in Balaclava harbour, she was tied up alongside the Glasgow-registered transport ship *Mohawk*, and the master of the transport offered Fenton the use of his launch to transport his equipment and materials ashore. Fenton's photographic van was manhandled to the bows of the *Hecla* before being winched on to the launch, its wheels barely resting on the sides of the small boat! The harbour was so busy, there had been no way the launch could have been brought alongside. Fenton reported that it was 'safely landed at last, after many hair-breadth escapes'.

Sir George Brown, centre, with his staff – Major Hallewell, Colonel Brownrigg, one of his orderlies, Colonel Airey, Captain Pearson, Captain Markham and Captain Ponsonby. Born and raised in Elgin, Scotland, Brown had started his military career with the 43rd Monmouthshire Regiment, and had seen action in the Peninsular War before assuming command of the Light Division in the Crimea. His horse was shot from beneath him at the Battle of Alma, and he was wounded at Inkerman. He later became Commander-in-Chief of the British forces in Ireland with the rank of General.

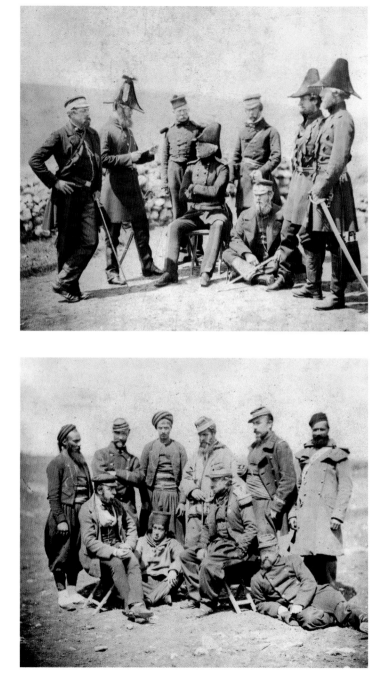

A multi-national group of soldiers in General Bosquet's Division poses for Fenton's camera.

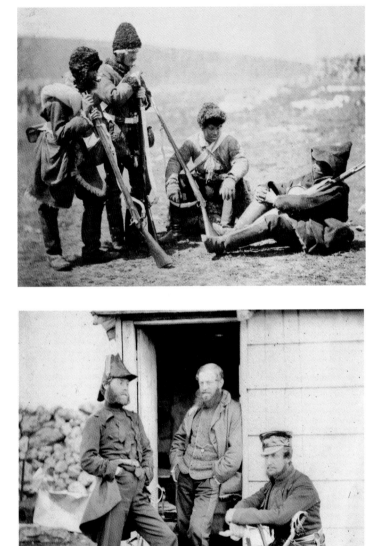

Men of the 77th East Middlesex Regiment, ready for the trenches. On 19 April 1855 The 77th attacked the rifle pits in front of the Redan, driving the Russians out with their bayonets and allegedly without firing a shot. They suffered high casualties, and their commander Colonel Egerton was himself killed.

Captain Ponsonby, Captain Pearson and Captain Markham, three of the officers on the staff of Lieutenant-General Sir George Brown.

A French *vivandière*, photographed by Fenton. *Vivandières* and *cantinières* were the wives of serving soldiers in the French and British forces respectively, and had authority to sell food and supplies to the soldiers of their regiments, over and above what they were given as free rations. Several remarried within the regiment if their husbands were killed in action, in order to maintain their franchises!

was spending the afternoon with a brother-in-law and some friends in the 88th with one of whom I had been intimate for several years. I was sitting in his tent with five officers of the regiment, being about to dine together, when Captain Layard brought orders for the formation of a column for the assault on the Redan, my brother-in-law being named as second-in-command of the storming party of 100 men, and our host as commander of the reserve. I shall never forget the sudden hush with which our previous mirth was quelled, nor the serious looks which went around the group of brave men receiving the message, which as they knew was to some of them the summons to another world. I accompanied them 'til they reached the trenches.

There was a fine young man whose face is before me now, as then, when I saw him for the first and last time. He had begged to be allowed to join the storming party in the place of another officer and his request had been, as I

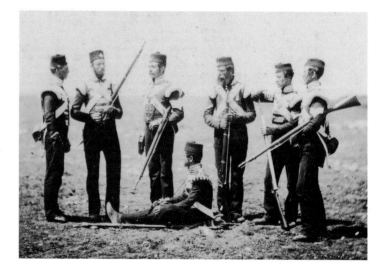

Men of the 68th Regiment. The imposing-looking weapons being held by these soldiers were Enfield Pattern 1853 Rifle-Muskets, .577 calibre muzzle-loading rifles, and the 68th was one of the first regiments to be issued with them. They were used by the Army from 1853 to 1867.

think, improperly granted. There was something inexpressibly painful to me in looking at the excitement and pleasure which his expression betrayed.

Having returned to a spot where the principal attack could be seen, I remained there for several hours, not knowing how time passed, and, like the rest of the group, scarcely conscious of the shot and shell which were hissing over our heads, except on one occasion, when a spent ball, which everybody saw coming, passed through the thickest of the throng, killing one man, who got confused in his efforts to avoid it. After everything seemed over, and the rattle of musketry grew faint, I returned to the camp and entering my brother-in-law's tent found him lying with a grape shot hole in the arm.

While sitting with him, to give him drink from time to time, I could hear in the next tent the moans of the commander of the storming party, who had been shot through the abdomen until about midnight, when their cessation told that his sufferings were over. From time to time a wounded soldier coming up told us how things were going on in the quarries. We could learn nothing of our friends, except that it was thought some of them were wounded. At last up came the report that one of them was killed, then another, and another, and as fresh stragglers arrived, rumours changed into certainty.

The handsome lad on whom I had looked with such interest was missing, and was said to be lying close to the Redan. With a heavy heart I rode back to my own quarters in the grey of the morning, meeting with litters on which were

Only once in all 360 of Fenton's photographs did he even hint that war had a brutal and lethal aspect. *The Valley of the Shadow of Death* was taken after the site had been stripped of the bodies of dead soldiers and horses. Three versions of this image were taken, each offering a different view of the hillside littered with over a thousand Russian cannon balls. Here is where photography won the day, for when William Simpson's illustration of the same title is compared with Fenton's photograph, the photograph chills while the lithographic print merely informs.

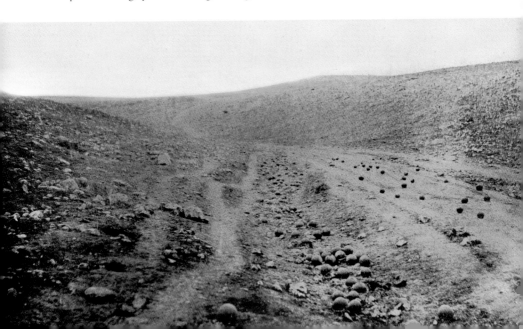

The Siege of Sevastopol, 1855 – not an original photograph of the war, but copy photographs from the 360° panoramic painting of the siege which is displayed in a huge rotunda in Sevastopol – several series of which were taken c. 1905. The rotunda was built to commemorate the fiftieth anniversary of the battle – the painting looked so real that monochrome photographs of it have often been mistaken for actual photographs. Largely destroyed by the Germans in 1944, the painting was recreated in 1955 to mark the centenary of the siege.

borne silently men with pale waxen faces and ghastly wounds. That afternoon I followed to the grave the bodies of three of the five who had met to spend the previous evening in social enjoyment.

A day or two afterwards, when dining with General Bosquet, and expressing to him the depression that these events had caused in my mind, I was much struck with his reply. 'Ah', he said, 'no-one but a soldier can know the misery of war: I have passed six and twenty years of my life burying my most intimate friends.'

From many others at the front, the stories were similar. One officer, Captain Garnet Wolseley, described the assault on the Redan Fort with poetic eloquence: 'If the ground over which the three British columns advanced upon the Redan looked at first like a field made bright with red poppies, it seemed, in the twinkling of an eye, as if struck by a hailstorm that had swept them away, leaving the field strewn with the poppies it had mown down.' When the Redan eventually fell, thousands were dead on both sides, and the destruction was immense.

Fifty years later, in 1905, the Russians commemorated the Siege of Sevastopol by commissioning a monumental 360° panoramic painting, which was displayed in a specially constructed rotunda. Inside, from a viewing position as if on the roof of the Redan, the battle scene is played out all around. Destroyed in the Second World War, the painting was recreated to

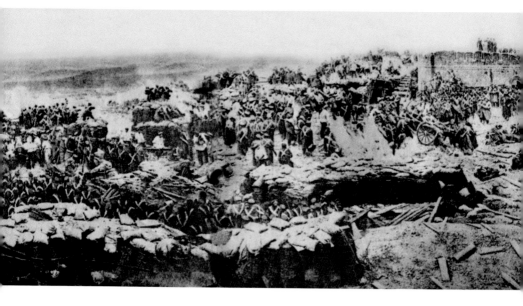

mark the centenary of the siege, and remains to this day one of the most remarkable sights in Sevastopol.

As several historians have observed, as the war drew to a close in 1856, the British High Command was almost ready to fight it – some vital lessons had been learned, but very harshly and much too late. At best, the outcome cannot really be classed as anything more emphatic than a draw. The Treaty of Paris, signed on 30 March 1856, was a compromise, with the allies conceding as much as they gained. And even one of their significant achievements, a guarantee that no warships would be based in the Black Sea, was repudiated by the Russians within fifteen years.

The Crimean War may have been badly managed and badly led, and the casualties much higher than would have been the case under enlightened leadership, but its importance in British military history cannot be overstated. It was the last of the old wars, and the first of the modern era – a war fought with modern weapons but outmoded tactics. The soldiers who cut their teeth on the Crimean battlefields were the future leaders of the British Army.

The conflict also changed how we view and talk about heroism, and radically altered the way in which the common soldier's contribution to success was measured and recognised. Amongst the more memorable legacies of the war, the actions of the 93rd Regiment, the Sutherland Highlanders, were immortalised on canvas after they stood their ground against vastly superior Russian forces at Balaclava, their 'thin red line tipped with steel' becoming the subject of several paintings and countless engravings.

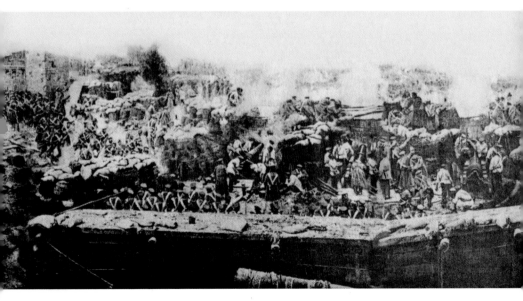

Two panels from the 1905 Sevastopol panorama, photographed, annotated, and published for the Russian market, c. 1906.

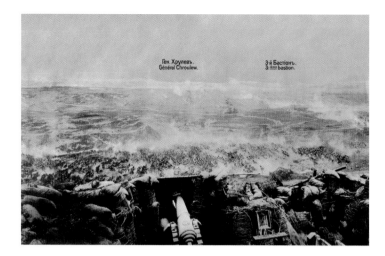

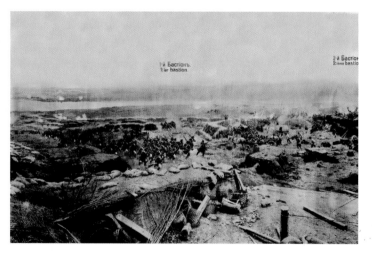

Opposite:
The recreated painting, completed in 1955 to mark the centenary of the siege, is housed in a specially built rotunda in Sevastopol. Photographed in 2002 as if from the roof of the Redan Fort, this section of the panorama offers a beguiling illusion – the three-dimensional foreground appearing to blend seamlessly into the painted 360° representation of the battle.

The original report of the incident by the *Times* correspondent William Howard Russell, described it as 'the thin red streak'. It was not until more than twenty years later in 1877 that the description was amended to 'the thin red line', a phrase which from then on has been used to epitomise unquestioning bravery in the face of overwhelming odds.

For eighty-five of the Crimean heroes, their exploits would result in them being included in the first list of men to be awarded the Victoria Cross. The simple Maltese Cross was made out of the bronze from captured Russian cannon, and the simple citation 'For Valour' was the suggestion of Queen Victoria herself.

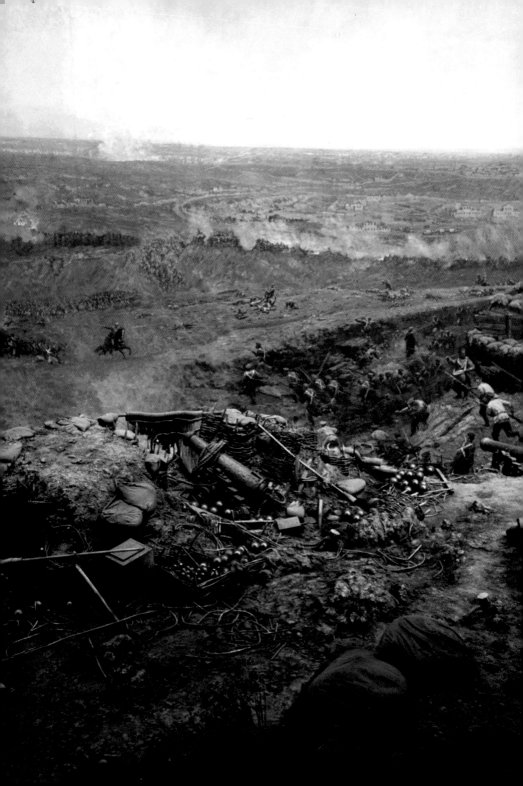

CAMPAIGNS IN INDIA

Given the undoubted value of the photographs produced during the Russian War in the Crimea – and the widespread use of photography by the British, the French and the Russians – it is perhaps surprising that there is such a paucity of photographic evidence of Britain's Indian conflicts. Perhaps this is due to the very different circumstances surrounding the

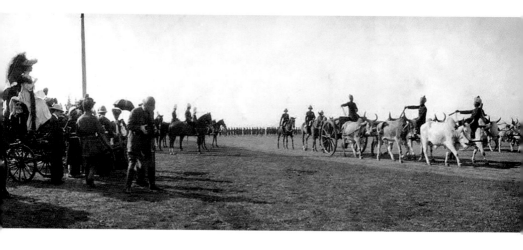

military engagements associated with rebellions – here Britain assumed the role of 'colonial master' quelling 'native uprisings' rather than that of an imperial power engaged in a conflict with an enemy of similar or greater influence. Thus, officially at least, it was perhaps seen as more of an internal matter, rather than a war fought on a more international stage. While newsmen were dispatched to report on such troubles, initially photographers were not.

Throughout Queen Victoria's reign, there was not a single year in which Britain was not engaged in conflict somewhere within the Empire, or within areas of interest which the British Government sought to add to the growing proportion of the world's land masses which they controlled and over which the Union Flag flew.

Until the 1850s, of course, photography was a primitive process, largely incapable of capturing anything but the perfectly posed, so the early uprisings in the areas now known as Pakistan were beyond the capture of the camera. The war artists reigned supreme, their idealised view of the battles and

From the earliest days of photography, several thriving photographic clubs were active in the Indian provinces. Gentlemen amateur photographers, as early as the beginning of the 1850s, had the benefit of specially written manuals through which to familiarise themselves with the very different conditions for photography which they experienced in the sub-continent. Thus, many of the demonstrations of force laid on by the British and their Indian allies were covered by the camera. These panoramic photographs, taken by an unknown photographer probably between 1895 and 1905, show British troops and Bengal Lancers parading in front of an audience of well-dressed civilians, while another photographer wearing a pith helmet (top image, left) also captures the proceedings.

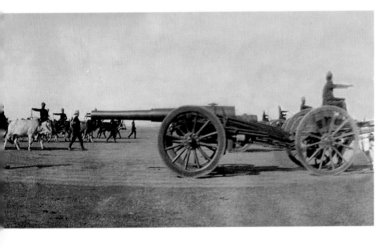

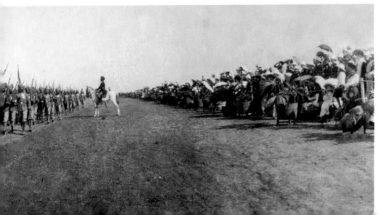

skirmishes no closer to the truth than the enduring myth – perpetuated by himself in the years after the event – that General Sir Charles Napier sent a one-word telegram, '*peccavi*', ('I have sinned'), after the decisive encounter which secured Sind province in 1843. That particular gem originated in the pages of *Punch* magazine rather than on any Indian battlefield.

Photography in India presented very different challenges to photography at home in Britain – the unique character of India's brighter light offered photographers shorter exposures and more candid observations, while the high humidity experienced through many months of the year presented problems of mould and mildew in cameras and lenses, and very different storage requirements for the chemicals.

The first photographers in India were, not surprisingly, members of the military, who carried cameras with them to use during their off-duty times. One of those, Dr John M'Cosh, a Scottish surgeon attached to the Bengal Division of the East India Company's Army, is credited with having taken some of the earliest photography on the sub-continent, and some of the earliest to show military equipment. His place in the history of military photography rests on a single album of his work preserved in London's National Army Museum. The first portrait in that album is believed to be of Vans Agnew, whose murder in 1848 by the local Hindu Governor Mulráj was one of the events which raised tension during the Second Sikh War. Also included in the album are calotypes M'Cosh took during the Second Burma War between 1852 and 1854.

After he had retired from military service in 1856, M'Cosh published a booklet entitled *Advice to Officers in India*, offering guidance on how to

British control over India expanded rapidly during the first decades of Victoria's reign, as Indian rulers were sidelined – allowed to keep their titles and trappings, but stripped of their power. A number of the several uprisings the British sought to quell were triggered by local revolts against that subjugation.

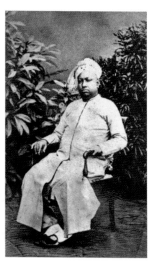

produce successful photographs, using both paper and glass negatives.

Before that time, lightweight bellows cameras – such as those designed by Marcus Sparling (Fenton's assistant in the Crimea) and Major Halkett – had become available, and by the time he wrote his booklet, such equipment was already commonplace for military personnel working throughout the Empire. But M'Cosh dismissed them as unsuitable for the extremes of the Indian climate. 'The camera', he wrote, 'should be made of good substantial mahogany, clamped with brass, made to stand extremes of heat. The flimsy folding portable camera, made light for Indian use, soon becomes useless'.

The problem, he believed, was humidity, which caused warping in the wood of lightweight instruments. And Dr M'Cosh remained un-persuaded, despite the fact that the manufacturers of these cameras believed them ideal for use in India. A decade later, another photographer working in India, Samuel Bourne, would express similar misgivings about their lack of rigidity, and tendency to warp.

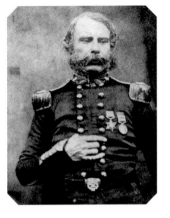
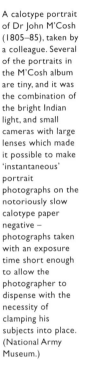

A calotype portrait of Dr John M'Cosh (1805–85), taken by a colleague. Several of the portraits in the M'Cosh album are tiny, and it was the combination of the bright Indian light, and small cameras with large lenses which made it possible to make 'instantaneous' portrait photographs on the notoriously slow calotype paper negative – photographs taken with an exposure time short enough to allow the photographer to dispense with the necessity of clamping his subjects into place. (National Army Museum.)

M'Cosh, a surgeon with the Bengal Infantry, photographed British guns in front of the Grand Pagoda at Prome during the Second Burmese War in 1852. Static subjects were ideally suited to the calotype process he was using. Even so, several of M'Cosh's surviving photographs show the tell-tale ghost-like figures of soldiers and servants unable to stand still for the duration of the lengthy exposure.

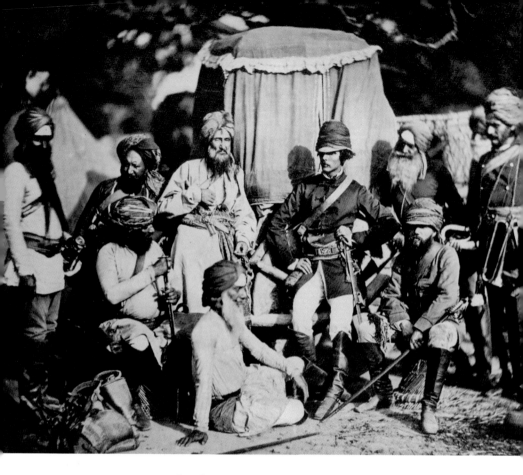

Hodson's Horse, an irregular Sikh cavalry which helped put down the Indian rebellion in 1857, became part of the British Indian Army in 1859, and was split to become the 9th and 10th Bengal Lancers. The central officer is probably Lieutenant Clifford Henry Mecham, and the seated officer, Assistant Surgeon Dr Thomas Anderson. The photograph was taken in 1858 by Felice Beato.

When the uprising which has become known as the Indian Mutiny began, it is hardly surprising that the official British response was very different to that which had been provoked by press reporting from the Crimea. At that time, the distances troops had to travel to the seat of the war, and the difficulties in establishing reliable supply lines, had stretched the British authorities to the limit. Sending a photographer to produce reassuring photographs was a pioneering and controllable undertaking. But it was, above all, a commercial rather than a military venture.

In military terms, India was a very different matter. Already there was a large and well-equipped garrison force of forty-five thousand men in place in the country – although many more would prove to be necessary – and established ordnance depots, and tried-and-tested supply chains already existed. An uprising staged by an indigenous population kept in almost feudal servitude was, initially, not thought to be a major threat.

As it turned out, that was far from the truth, and it would have been impossible to use photography to put a gentler face on the scenes of death

and destruction which resulted from the severe measures the British took in quelling the uprising.

According to some sources, Constantinople-based James Robertson was appointed as official photographer to the British forces in India in 1857, although history has attributed most of the most compelling images of the uprising and its aftermath to his brother-in-law and one-time assistant, Felice Beato. The two men had worked together since 1855 when Beato had collaborated with Robertson

Also photographed by Beato was Major-General Sir James Hope Grant. A veteran of several Indian campaigns, he arrived in India in 1844, and fought in the Sikh Wars between 1845 and 1849. After the Indian Mutiny, Grant was knighted and promoted to Major-General in 1859, and during the Opium War in China in 1860 he brought about the surrender of Peking. He returned to India in 1862 as Commander-in-Chief of the Madras Army.

in making some of the most compelling images of the Crimean War, all taken after Roger Fenton had returned home ill.

But by early 1858, it would appear that Beato had established his own studio in Calcutta, and at the time of the quelling of the uprising, he was therefore working alone. That begs the question: what became of Robertson's work if, indeed, he was working as 'official photographer' to the garrison forces?

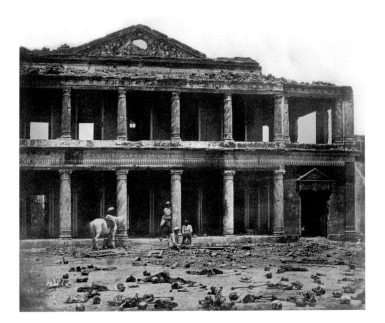

The Secundra Bagh, Lucknow, after the 93rd Highlanders had routed the insurgents. British dead were buried in a mass grave, but one report claimed that the bodies of the 1,850 rebels rotted where they lay, 'prey to the vulture by day, and the jackal by night'. Not quite true: to recreate this scene in the spring of 1858, Beato is said to have arranged for the bones of the Indian dead to be dug up and scattered for visual effect!

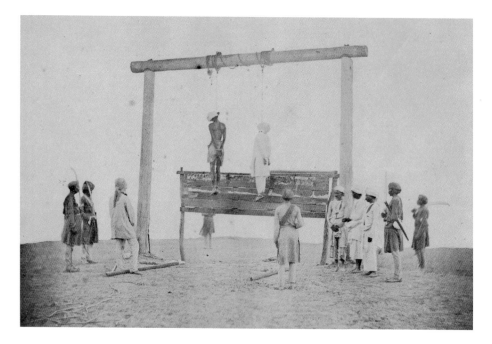

Two Sepoys of the 31st Native Infantry hanging, Felice Beato, 1858. British reprisals were brutal, with hundreds butchered, and many more executed.

It is also interesting to note that in the diaries and journals of several British officers who served in all three theatres of war – the Crimea, India, and then China, there are many mentions of 'Signor Beato', but very few mentions of Robertson. Despite several sightings with his camera in the Crimea, no images signed by Beato survive from that war.

In 1857–8, photography was, of course, still unable to show action, but unlike in the Crimea, in India Beato made no attempt to sanitise the scenes of conflict. In the Crimea, Robertson and Beato had waited until the corpses had been cleared away before moving in with their cameras, but not so in India. Here it was claimed that the rotting bodies – all of them Indian – were dug up and scattered across the ground, giving the photographs a shocking message for Victorians usually shielded from such stark actuality.

Perhaps portraying the dead as 'mutineers' against the Queen Empress introduced some sort of moral justification for the brutality. Photographers, generally, still shied away from provoking the shock which would have been triggered by photographs of dead British soldiers.

The uprising had been provoked in large measure by British attempts to take away the power of the native rulers, and was exacerbated by the breakdown of discipline in the East India Company's armies. The veteran war correspondent William Howard Russell, whose Crimean reports had moved the nation, was less than complimentary about British rule in India.

'That force is the basis of our rule, I have no doubt', he wrote, adding: 'The grave unhappy doubt which settles on my mind is, whether India is the better for our rule, so far as regards the social condition of the great mass of the people.' The discovery that the cartridges for the Enfield rifle were greased with pig and cow fat – the former unclean to Muslims and the latter sacred to Hindus – proved to be a catalyst. One might have expected Benjamin Disraeli's Jewish background to make him sympathetic to the feelings of the Muslims but instead, he merely observed that 'The rise and fall of empires are not affairs of greased cartridges.'

When the rebellion broke out, there was, perhaps, no obvious profit incentive in sending a photographer all the way to India. Even in the case of Fenton's Crimean images, the commercial failure of the enterprise – and the auctioning in 1856 of the huge unsold stocks of prints – can hardly have been an encouragement for any would-be entrepreneur. Images of the aftermath were certainly not the sort of thing which would, or could, be openly displayed in Victorian drawing rooms.

With hindsight, we can see that the brutality of the British in quelling the rebellion was designed to send a very clear message to the indigenous communities. For those who saw them, Beato's photographs strongly underlined that message.

Hundreds of rebels were executed by firing squad, or by being 'blown by guns' – tied across the fronts of gun barrels and blown to pieces. An illustration from the *London Illustrated Times*, 1857.

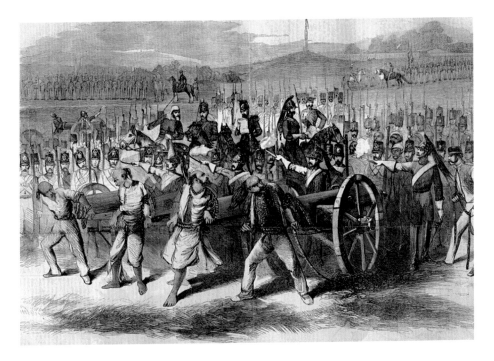

ENGAGEMENTS IN CHINA

BRITISH MILITARY involvement was rarely restricted to just one area of the world at any given time. While the last incidents of the Indian uprising were being brutally put down, the British were already preparing for further action in China, despite the fact that the recent signing of the Treaty of Tientsin in June 1858 had been intended to finally bring to an end the hostilities which had lingered after the end of the Second China War more than a decade earlier. The British even had to engage in minor action at Taku just to get to the treaty signing.

Britain's commercial and military involvement in China was deeply rooted in the highly lucrative opium trade between India and China, and the widespread addiction to narcotics along China's eastern seaboard was a considerable cause for concern amongst the local authorities. The so-called 'Opium War' of 1840–2, triggered by the Chinese seizure of Britain's large stocks of opium in late 1839, would have long-lasting implications. From the Treaty of Nanking at the end of that war came the ceding of Hong Kong to Britain in 1842, and a short-lived, uneasy peace during which Chinese disquiet grew over the trading practices in the European enclaves within Canton and other ports.

Although there was heavy involvement of British forces, the war in China was not universally endorsed at home, despite the enthusiasm of Lord Palmerston and the East India Company, which profited from the trade. Gladstone, an avowed opponent of British involvement, rounded on Palmerston in a speech in which he claimed that Britain's flag 'has always been associated with the cause of justice, with the opposition to oppression, with respect for national rights, with honourable commercial enterprise, but now, under the auspices of the noble lord, is hoisted to protect an infamous contraband trade.' There were many parts of Britain's growing empire where the indigenous, and by then subjugated, peoples would have readily taken him to task over some of those assertions!

A further conflict erupted in 1846 – usually referred to as either the Second China War, or the *Arrow* War, so named after the British schooner

Opposite:
Pehtang Fort in north-eastern China after the British and French occupied it on 1 August 1860. Felice Beato, who had travelled to China after his photography of the Indian Mutiny, recorded the raising of the British flag over the captured fort. Arriving in China in April, Beato accompanied an expeditionary force sent to punish the Chinese once again for what the British saw as their rebelliousness in trying to curb the opium trade.

Three weeks after the taking of Pehtang, Beato photographed the carnage after the assault on the Taku Fort on 21 August 1860. The Taku forts occupied a strategic position with clear firing lines across the Hal estuary. Britain had first occupied them during the First Opium War, and shelled them on several occasions during subsequent conflicts. Beato, using the same stark approach to his photography as he had in India, did not wait for the removal of Chinese corpses.

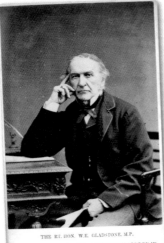

William Ewart Gladstone, a strenuous and vocal critic of the First Opium War in China.

THE RT. HON. W.E. GLADSTONE. M.P.

ELLIOTT & FRY. Copyright. 55, BAKER S^T LONDON. W.

Prince Kung, brother of Chinese Emperor Xianfeng, was the signatory on the Convention of Peking, signed on 2 November 1860, which brought the hostilities of the Second Opium War to an end.

involved in what the Chinese decreed were acts of piracy. So while the British were already engaged in the Sikh Wars in India, a large squadron of British warships was in the South China Sea, once more shelling Canton. Unbowed by repeated criticism, a few years later, in the build-up to the third war, Palmerston was reported as saying, 'The time is fast coming when we shall be obliged to strike another blow in China.' All to defend the narcotics trade – although the official position of both the British and French was that they were forced into action by Chinese reluctance to embrace the idea of free trade!

Less than a year after the signing of the Treaty of Tientsin in 1858, trouble erupted once again, with the Chinese shelling the British fleet from the Taku forts at the mouth of the Hal River in Tianjin in north-eastern China. This time the British lost, suffering a humiliation which they found hard to bear, and in an attempt to restore their own honour, they declared war on China on 8 April 1860. By 1 August a sixteen-thousand-strong British force had landed at Pehtang. Within hours, they had captured the important Pehtang Fort, and Felice Beato was there to photograph the moment. Three weeks later he photographed the ruins of the hugely strategic Taku Fort after it, too, had fallen to the British and French. By mid October the allies were in Beijing, eager for revenge. Sacking the Forbidden City was considered an assault too far if peace was ever to be restored, so instead the British and French leaders, Lord Elgin and Baron Gros, sent Captain Charles 'Chinese' Gordon and the Royal Engineers to loot and destroy the Imperial Summer Palace at Yuanmingyuan just north of the city.

Just what Beato's status in China was remains – like most of his life – shrouded in obscurity. He certainly had caught the eye and

the ear of the British high command, and they appear to have, at least, smoothed his passage to China. There is no extant evidence to afford him any official status, so the likelihood is that, like Fenton in the Crimea fifteen years earlier, his was primarily a commercial venture, albeit with doors opened and access assured thanks to his friends in high places. While in China, he produced a large body of architectural and scenic views, which appear to have sold widely, as indeed did several of his more harrowing images of the war.

Contemporary accounts simply refer to him as 'the professional photographer who followed the army', but he was more than just that. He had the authority to go into recently captured forts with his camera within minutes of them being secured, and to insist that the bodies not be moved until he had photographed them. His reported quest for 'picturesque groupings' within the carnage may seem odd to us today, but Beato's images undoubtedly now define the war from the point of view of the British and French.

They also move war photography into the era of greater realism, with the acceptance that people die. That the deaths which stared out from the prints were the enemy, offered a stark visual reminder of the might of the victorious British.

The ruins of the old Imperial Summer Palace still lie in Yuanmingyuan Park near Beijing. It was destroyed by the British in October 1860 after the Chinese executed British and French prisoners-of-war. The attack was led by Captain Charles George 'Chinese' Gordon of the Royal Engineers. As 'Gordon of Khartoum' he would later play an even more pivotal role in Britain's military history. After the raid he wrote, 'The people are civil, but the grandees hate us, as they must after what we did to the palace. You would scarcely imagine the beauty and magnificence of the places we burnt. It was wretchedly demoralising work for an army.'

THE AFGHAN WARS

From one of John Burke's *Afghan War* albums, a group portrait taken on location in the Afghan mountains in 1878 or 1879. He regularly travelled with the forces during their campaigns on the North-West Frontier, and their incursions into Afghanistan.

Britain's current involvement in Afghanistan might, quite reasonably, be referred to as the Fourth Afghan War, for there have been three major British engagements in that country, two of them in the nineteenth century.

Having received erroneous intelligence in 1837 about alleged Russian plans to invade Afghanistan, the British Army in India was readied for invasion, and a force numbering more than twenty-thousand British and Indian soldiers crossed the border from the Punjab in early 1839, and marched towards Kabul. Their military engagements included both victories and catastrophic defeats before they withdrew through the Khyber Pass in 1842 leaving Afghanistan to its own resources – and increasing Russian dominance over the next thirty years.

All that, of course, was before the days of photography, but by the time the British forces returned to Afghanistan in 1878, photography had evolved

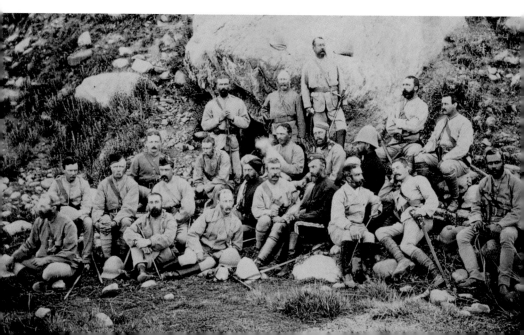

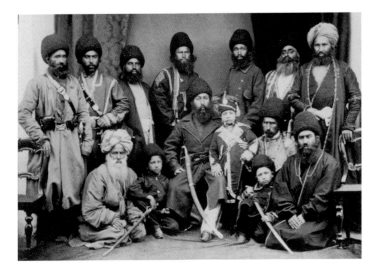

Also by John Burke, this group study comes from a series taken at Amballa in the Punjab in March 1869, and shows the Amir Shere Ali Khan of Afghanistan seated centre. The Amir had recently come to power, and was openly hostile to British plans to establish an embassy in Kabul.

as a capable recording medium – and, with a successful photographic studio in Peshawar, a former Royal Artillery apothecary, John Burke, was available to accompany the troops. His military background may have eased his access to the British forces, and he covered their campaigns in the region over nearly twenty years.

Britain's involvement in Afghanistan in the late 1870s had grown out of heightened tensions between Britain and both Afghanistan and Russia, but took the form of plans to replace an Afghan government seen as increasingly in thrall to the Russians. Again, victories and setbacks came in relatively equal measure, with periods of uneasy peace in between, before General Roberts claimed victory after a momentous march from Kabul to Kandahar in October 1880.

During the first 'peace' in 1879, Burke published the first of his *Afghan War* albums, 'Illustrating the advance of the Peshawar Field Force from Attock to Jellalabad', with a cover price of 200 rupees. He initially sold his albums from his Peshawar studio, but interest in his work quickly spread, and his photographs were offered through bookshops and print sellers in India's major cities, as well as in London.

After the shock and horror of Beato's photographs of India and China, Burke's Afghan campaign images are more in the style of Fenton's oeuvre in the Crimea a quarter of a century earlier – camp scenes, individual portraits of the main protagonists, and groups of soldiers.

The British remained in occupation until the spring of 1881, the majority of the troops involved being from the Indian rather than the Imperial army, and eventually withdrew with little to show for their endeavours.

THE WAR IN ZULULAND, 1879

T HE BRITISH commander during the Anglo–Zulu War of 1879, Lieutenant-General Lord Chelmsford, made no attempt to disguise his intense dislike for the body of war correspondents resident in his camp. He mistrusted them, accusing them of misreporting and bias, though conceding that such errors may well have been due to ignorance of the fine points of military operations rather than malice. But amongst that media contingent, there were few photographers riding with the troops – surprising, given widespread interest in photographs of war, and the general acceptance that the line illustrations used in newspapers and periodicals were best drawn from photographs. If surviving images are typical, the majority of photographs were taken either of 'the coming war', or safely after hostilities had long ceased.

Henry and Benjamin Kitsch, with studios in Pietermaritzburg and Durban, fall into the former category, with James Lloyd of Durban in the latter. Only one name stands out as having photographed during the campaign, and that was George Ferneyhough, with a studio at 12 Longmarket Street, Pietermaritzburg, who accompanied Colonel Woods's column. His *Catalogue of Photographic Views of the Zulu War* was published in the early 1880s and contained fifty-five photographs. But it was Lloyd's albums of photographs, published between 1879 and 1880, which attracted the praise and approval of the Natal press. *The Natal Witness*, in August 1879, described several photographs taken in the vicinity of both Isandlwana and Rorke's Drift:

Photographs of the Anglo–Zulu war remain rare, with the most frequently seen being those by James Lloyd of Durban. The camp scene, below, was taken by Lloyd at Utrecht and behind the tents can be seen the hospital building used by Sister Janet Wells, from whose scrapbook it comes.

Sad tokens of the awful slaughter with which the surrounding scenery is so bitterly associated lie in the foreground of several views, which have as an imposing background the lofty mountain crag of Isandlwana, while the empty wagons

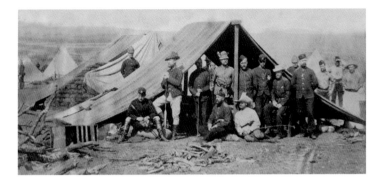

Also from Sister Janet's scrapbook, this group is titled 'Camp of the 80th Regiment, South Africa, 1879.' Many soldiers from the 80th Regiment (Staffordshire Volunteers) were killed during an attack by eight hundred Zulus at Myer's Drift.

which lie dotted here and there remind us of the long unavenged spoliation of Cetywayo's hordes.

Powerful, and typically jingoistic stuff.

British interest in southern Africa had dwindled in the 1850s, but the discovery of diamonds had rekindled it. The Transvaal was annexed in 1877, and with it came a rumbling unease between Transvaal and Zululand with frequent border incidents throughout 1878, erupting into war in January 1879. British forces were surprised to find the Zulu nation, led by Cetshwayo kaMpande and with an army numbering nearly fifty thousand, a formidable and clever foe – and a resounding defeat at Isandlwana at the hands of some fifteen thousand Zulus sent shockwaves back to Britain, albeit some weeks after the battle due to very poor lines of communication.

The British media, however, chose to elevate the heroic defence of Rorke's Drift, thus playing down what was one of the worst defeats ever suffered by Victoria's armies. By July 1879, the tables had been turned, and the British had routed the Zulus at Ulundi, effectively ending the war. The correspondent from *The Natal Witness* wrote, 'The war will long be remembered among the Zulu people, as fully one half of their young men have been killed since the outbreak of hostilities.'

After hostilities ceased, the deposed Cetshwayo – crowned King of the Zulus by the British and then defeated by them – would spent part of his exile in London!

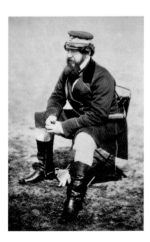

The Anglo–Zulu War was the last to be covered by the veteran war correspondent William Howard Russell – seen here in an 1855 photograph by Roger Fenton – who had risen to fame with his campaign reports from the Crimea a quarter of a century earlier. His accounts of British behaviour after the war were no less scathing than had been his reports from the Crimea.

THE FIRST
ANGLO–BOER WAR

IF THE battle of Isandlwana during the war in Zululand has gone down in history as the worst defeat suffered by Victoria's armies in battle, then what is today known as the First Anglo–Boer War – although in South Africa it is considered by many to have been the third – must go down as the only war Victorian Britain ever lost.

Hostilities began in December 1880, by which time photographers were no longer having to take mobile darkrooms with them into the field. They were using more easily transportable equipment, and commercially produced dry plates – yet, like the Zulu war in the previous year, photographs of the conflict are relatively few. The most informative are those taken by a few officers who carried their bulky cameras with them. Again, no official photographic presence has been confirmed, despite it being, by this time, almost a quarter of a century since the Royal Engineers had started training officers in photography – especially those about to be posted overseas. Training had started first in Chatham in 1856, and later at Woolwich, and had been enthusiastically embraced by, amongst others, the East India Company.

The war was a brief affair, lasting just over three months from mid December 1880 until late March 1881. Its origins can be traced back to Britain's annexation of the Transvaal in 1877, and rumbling Boer unrest over both the loss of their sovereignty and the ineptitude of Britain's governance of the province.

Things came to a head in the summer of 1880 when Britain refused to countenance restoring Transvaal's independence, and the Boers declared a republic in early December. Their highly mobile

Majuba Hill, an extinct volcano near Laing's Nek, was the scene of a notable British defeat on 27 February 1881. Sir George Colley and his troops were overwhelmed by the Boers and Colley was killed.

forces, some seven thousand in number, were skilled in guerrilla and commando-style warfare, employing tactics against which the British seemed impotent.

The British knew that they had to score an early and decisive victory over the Boers, but it just did not happen. Their first attack at Laing's Nek ended in failure, as did their engagement at Majuba Hill, and at home Gladstone's government insisted that negotiations be initiated towards an armistice.

The lessons of defeat were not learned, and eighteen years later when the second war started, the Boers employed those same commando tactics to costly effect.

It fell to Swiss-born and Pretoria-based photographer H. Ferdinand Gros to photograph scenes in the forts, camps and redoubts held by the British forces. The photographs were commissioned not by the military authorities, but by Charles Duval – sometimes styled 'Du Val' – who published a newspaper *News of the Camp,* the first edition of which appeared on Christmas Day 1880. Photographs, of course, could not yet be published in newspapers, but Duval announced early on that bound copies of the entire output would be offered for sale after hostilities ceased. He commissioned Gros to produce photographs which were sold alongside the bound copies. Twelve large views cost 30 shillings with small prints at 18 shillings.

Heavily armed and highly mobile Boer commando units were well-versed in guerrilla warfare. The British were ill-prepared to deal with them, and failed to learn from their defeats at their hands.

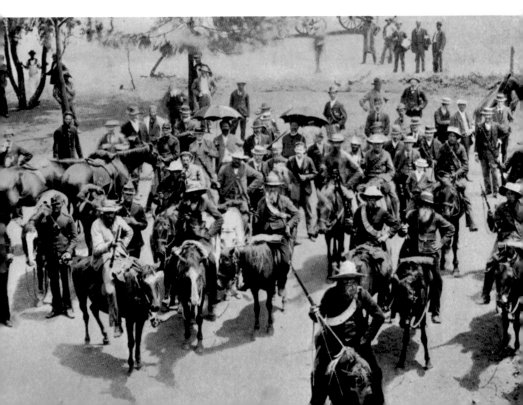

WARS IN THE SUDAN

B RITAIN'S involvement in the wars in Sudan had grown out of an unplanned alliance with Egypt – against whom the British had been fighting just a few years earlier to protect their interests in the Suez Canal. That conflict had left Britain acting as guarantor and protector of the finances of the bankrupt Egyptian government, and compelled to side with the Egyptians when the Sudanese under Mohammed Ahmed, known as the Mahdi, rebelled against corrupt Egyptian rule. That triggered two decades of unrest and sporadic conflict which included major battles at Tamai and El Tab in 1884, and the assassination of General Gordon in January 1885.

The British were quick to retaliate and amassed a considerable force to re-take the country and avenge Gordon's death, including several Native Infantry regiments from India. Under the command of Lieutenant-General Sir Gerald Graham, the troops landed at Suakin (present-day Sawakin) in March 1885. Despite two early victories, their progress was halted by a major defeat, and they withdrew completely leaving the Mahdists in control.

British forces did not return to the country until 1896. This time led by Kitchener, they won major victories at Atbara in April 1898, and Omdurman in September. At the Battle of Omdurman, veteran war correspondent Bennet Burleigh reported on the action. He was not short of admiration for the courage of the Mahdists, however futile might have been their action:

General Charles 'Chinese' Gordon (1833–85) in formal dress as Governor-General of the Sudan, a post he held from 1877 until 1880. As a result of his turbulent years in the region, 'Chinese Gordon' became 'Gordon of Khartoum'. He had first seen service as an officer in the Royal Engineers during the siege of Sevastopol in the Crimea in 1855, and had risen to prominence during the Second Opium War in China. His final years were spent fighting in the Sudan and he was killed and decapitated by Mahdist soldiers on 26 January 1885. After the British recaptured Khartoum in 1898, an extensive search failed to locate his remains.

Few will ever see again so great and brave a show. A vast army, with a front of three miles, covering an undulating plain – warriors mounted and a-foot, clad in quaint and picturesque drapery, with gorgeous barbaric display of banners, burnished metal, and sheen of steel – came sweeping upon us with the speed of cavalry. Half-a-dozen batteries smote

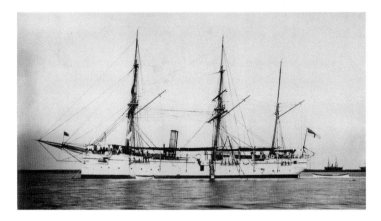

The Royal Navy's HMS *Dolphin* opened fire off Suakin on 8 March 1885 to cover the troops' advance inland. (Archive of Modern Conflict.)

them, a score of Maxims and 10,000 rifles unceasingly buffeted them, making great gaps and rendering their ranks in all directions. With magnificent courage, without pause, the survivors invariably drew together, furiously, frenziedly running to cross steel with us. Their ardour and mad devotion won admiration on all sides in our own ranks. Poor, misguided Jehadieh and hocussed Arabs of the spacious and cruel Soudan!

The camp of the Native Infantry, Suakin, March 1885, photographer unknown.

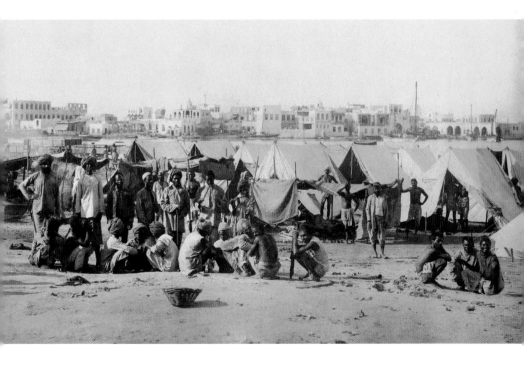

Top: Five years after the end of the war, soldiers from the 6th Dragoon Guards (Carabiniers) were persuaded by a postcard publisher to recreate a scene from their encounters with Mahdist forces in the Sudan – often referred to by the British as 'Dervishes'.

Centre: Colonel Wingate and his Staff Officers photographed at Dakhala, 1898.

Bottom: British artillery at the Zareba during the Battle of Omdurman. 'Whilst our batteries were hurling death and destruction from the Zareba at the Khalifa's army,' wrote Burleigh, 'Major Elmslie's battery of 50-pounder howitzers was battering the Mahdi's tomb to pieces and breaching the great stone wall in Omdurman. The practice with the terrible Lyddite shells was better than before, and the dervishes, even more clearly than we, must have seen from the volcanic upheavals when the missiles struck, that their capital was being wrecked.'

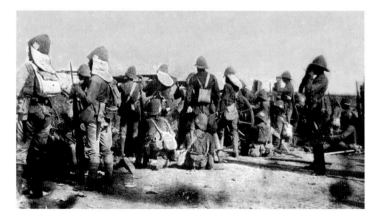

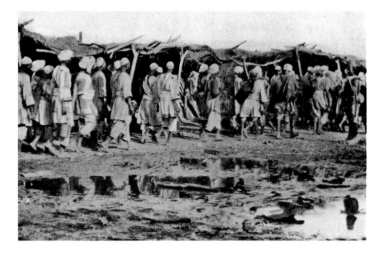

Fresh Batch of wounded and unwounded Dervish prisoners, Omdurman, 4th Sept. 1898, an illustration from Bennet Burleigh's 1899 account of the conflict. In it he wrote, 'All the enemy, however, who showed the least disposition to surrender were left unmolested.'

British advances continued, leading to the recapture of Khartoum and the establishment in January 1899 of what became known as Anglo-Egyptian Sudan.

Several photographers from the Royal Engineers were present during the ongoing unrest in the Sudan throughout the 1880s and 1890s. Images from their time in the Sudan were added to the regiment's growing photographic library which had been started during the Crimean War. Other photographers working during the conflict include Lieutenant E. D. Loch of the Grenadier Guards, whose albums survive, as do photographs by Francis Gregson. Both are credited in Bennet Burleigh's book *Khartoum Campaign 1898, or the Re-conquest of the Soudan*, Chapman & Hall, London, 1899.

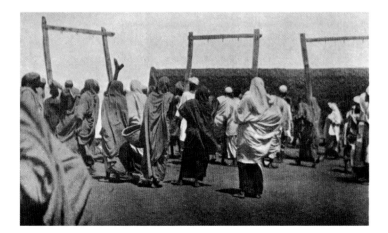

Khalifa's Gallows – cutting down his Last Victim, a poignant image recalling the brutality shown towards both British and native prisoners. The gallows 'were almost daily in use', according to Burleigh.

THE SECOND
ANGLO–BOER WAR

A SECOND CONFRONTATION with the Boers had been inevitable for some time before hostilities broke out in the closing months of 1899 and, as the correspondent for *The Times* reported from Pietermaritzburg on 11 October, 'At last the long weary crisis seems about to culminate, and before the end of the week it seems probable that a state of war will have begun. The diplomatic situation in face of the Boer ultimatum makes this almost inevitable, and the reported movements of Boer commandos points to the same result.'

Arthur Scaife, author of *The War to Date (March 1, 1900)*, wrote:

> As hope of a pacific solution gradually died away, all eyes turned to Natal, obviously the objective of Boer attack, and dread lest important successes should be scored prior to the arrival of reinforcements seized the public mind. The landing, therefore, of a contingent seven thousand strong, consisting of Royal Artillery, 5th Dragoon Guards, Gordon Highlanders, and 3rd Rifles from India, before the actual outbreak of hostilities, was hailed with a feeling of intense relief.

Hostilities began with Boer incursions from Transvaal into several British strongholds in Natal and Cape Colony, and around Kimberley and Mafeking, using highly mobile mounted commando units.

The inevitability of the war had meant that teams of newspaper reporters were already in place, and indeed some were even accused of complicity in provoking conflict!

In terms of reporting the action, the Second Boer War marks the beginning of the modern era. Whereas the First Boer War in 1881 had been fought at a time when the mechanical reproduction of photographs in books was still problematic, and an impossibility in magazines and

Sitting for a cabinet portrait in uniform before setting off for the South African war was not an uncommon practice. The significance of the tambourine at the soldier's feet is not known.

Henry G. Dyas LEVEN.
FIFE.

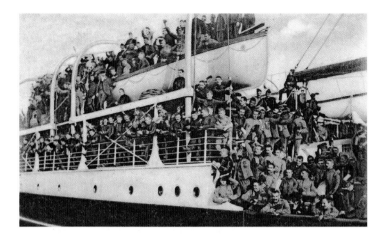

The 6,763 grt SS (RMS) *German* was built for the Union Steamship Company in 1898. In 1900, under the Union-Castle Line colours, she was used as a Boer War troop transport. In 1914, at the outbreak of the First World War, she was, perhaps not surprisingly, renamed RMS *Glengorm Castle*.

newspapers, the 1899–1902 war occurred when printing pictures was becoming much easier. The other innovation which makes our view of the war all the more vivid, is that despite quite rigorously enforced censorship, illustrated magazines and books were actually published during the war itself, giving the people back home a running account of progress, the setbacks, and a detailed back history of why Britain was involved.

Magazines such as *Black and White*, and *Black and White Budget*, published weekly at 6d and 2d respectively, proudly proclaimed that each issue contained *the Most Unique Photos and Sketches of the War up to Date*. A mixture of photographs and artists' impressions graced the pages, together with often-jingoistic accounts of the progress of the campaigns. *With The Flag to Pretoria* also contained a mix of sketches and photographs, and was published in fortnightly parts from March 1900, again priced 6d, while the weekly news magazine *The Sphere* restricted itself to sketches. During the Great War of 1914–18, it would still publish artists' impressions where action photographs had proved impossible to obtain. A stream of books was published during the first year of the war, many of them illustrated with

Not long after they arrived in South Africa in the summer of 1900, a group of Scottish soldiers was photographed by one of the author's ancestors using his Kodak camera. The Kodak camera had been introduced a dozen years earlier and had quickly enjoyed huge popularity despite its high price – and because officialdom did not think such photographs posed any threat, amateur photographers were only very rarely subjected to any censorship.

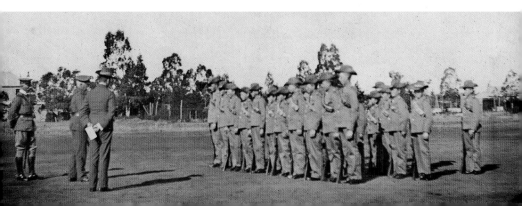

'Hill Climbing with the Maxim Gun' was one of the many illustrations included in *The War to Date (March 1, 1900)*, Arthur H. Scaife's account of the background to the war – and progress in it – published by T. Fisher Unwin of London. Scaife's book covered the period up to the end of March 1900.

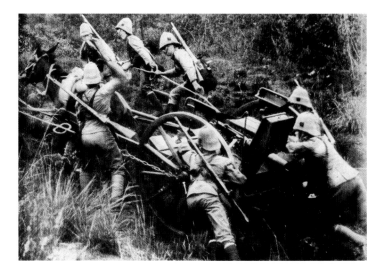

An Edwardian postcard of the Natal Field Artillery, published *c.* 1904. Established as the Durban Volunteer Guard in 1862, the regiment saw extensive action during the Second Anglo–Boer War.

photographs, offering readers an insight into the background to the conflict. Some publishers were unashamedly partisan in their reporting of events.

And throughout the campaign, the progress of the war was witnessed and interpreted by some of the leading writers and photographers of the early twentieth century. Working for the *Morning Post*, for example, was one Winston Spencer Churchill!

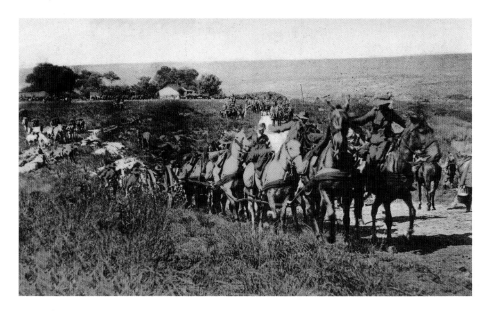

GENRL· BULLER & PIONEER Cigarettes are in **Everyone's Mouth** and have **Gone to the —Front—** owing to their **Superiority** over all **Others**

General Sir Redvers Henry Buller VC GCB GCMG, c. 1905. Before the Second Boer War – during which he was one of Britain's senior commanders – Buller had served in South Africa in both the Cape Frontier War of 1878 and the Anglo–Zulu War of 1879 where, as a Colonel, he was awarded the Victoria Cross. Buller was something of an eccentric general and defeats at Magersfontein and elsewhere led to questions about his leadership, but he remained well respected by the British public, who bought postcards of him in their thousands. His name was even used to help advertise a brand of cigarettes (top right). Buller returned to Britain in 1900 to a desk job at Aldershot, and died in 1908.

Just as with today's war correspondents, the reporters travelled with the troops, and often came under attack themselves. On one occasion Churchill was accompanying the Durham Light Infantry on a reconnaissance mission when the train on which they were travelling was attacked near Chieveley. Several soldiers were killed and many more wounded. Churchill, reportedly returning to help the wounded, was taken prisoner. A contemporary account reports that 'In consequence of his intrepid action [he] had great difficulty in persuading his captors at Pretoria that he really belonged to the non-combatant ranks. His escape from the schoolhouse where he was confined with the British officers, formed one of the most thrilling incidents of the war.'

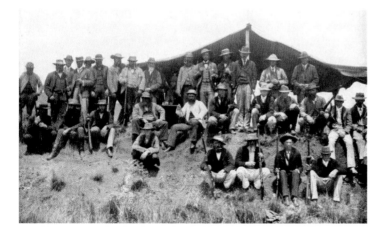

Boers at target practice. The guerrilla tactics of the highly mobile Boers caused the British high command almost as much trouble in the 1899–1902 war as they had done nearly twenty years earlier.

89

Loading a gun carriage in the camp of the Irish Brigade, early 1900. The courage and resilience of the Irish Brigade resulted in many casualties, and their attempt to capture Pieter's Hill exacted a heavy toll – so much so that, after several days of fighting, the Boers agreed to cease fire on the Sunday to allow the Irish to retrieve their dead and wounded soldiers who had lain untended on the hillside for up to three days.

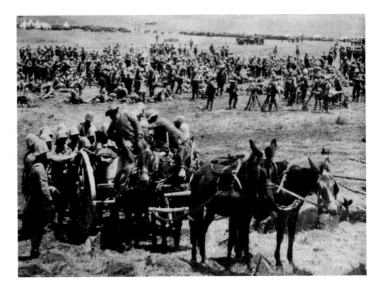

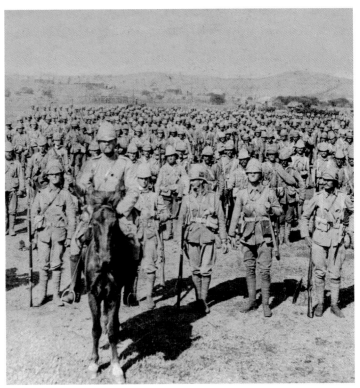

'A Halt outside Pretoria' – soldiers pause in early 1900 for the cameras of The Fine Art Photographers' Publishing Company of London.

Between them, the reporters chronicled the often difficult campaigns in which the British engaged, but they were subject to varying degrees of censorship as the war progressed. Their journalistic training, and the need to be accessible to their wide readerships, required them to paint a broad picture of the action they witnessed, and of course, to avoid saying anything which might help the enemy. Thus many published accounts are often some distance removed from the

individual and personal experience of the soldier in the trenches. Some of the most engaging accounts, therefore, survive in the private letters written by the soldiers themselves. It is only to be expected that private correspondence was subject to lighter and more arbitrary censorship than the writings of the professional journalists.

Winston Churchill received a hero's welcome when he returned to Durban after escaping from Boer captivity at Chieveley.

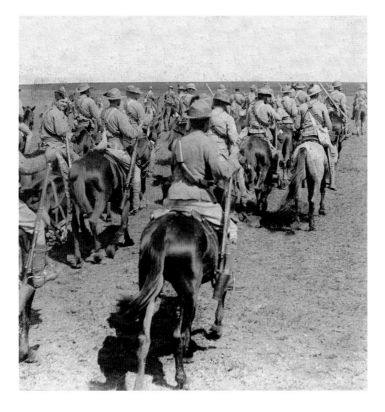

'Boer War, riding across the Veldt' – a detail from a stereoscopic card produced in early 1900.

'Gun Firing cordite'
– one of a series of
photographs by
René Bull, 'Our
Special
Correspondent with
General Buller',
showing the 7th
Battery in Action,
and published in
*Black and White
Budget* magazine
on 17 March 1900.

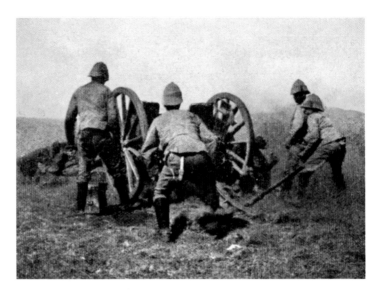

Unidentified cavalry
moving towards
Ladysmith, 1900 –
detail from a
stereoscopic view.

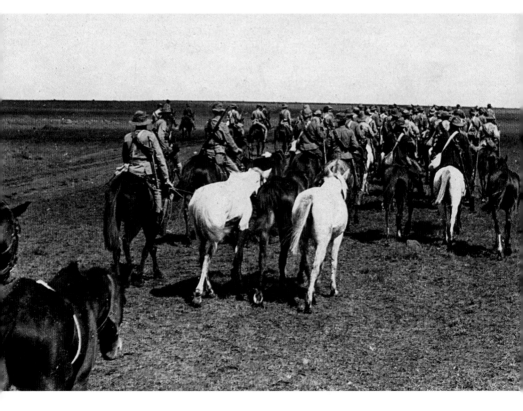

Published by Underwood & Underwood, from their 1900 series of stereo-views of the progress of the war, this card is entitled 'Responding to the call of a beloved Queen – Arrival of a British Transport, South Africa'.

British Cavalry moving towards Ladysmith, 1900. Photographed by B. L. Singly for the Fine Art Photographers' Publishing Company of Rydevale Road in London.

Writing to a friend, a private in the Highland Light Infantry described the attack on the Boer trenches at Magersfontein on 11 December 1899:

We were at Modder River, and we started out with two days' food with us, and at eight o'clock that night we halted two miles from their big hill, called the fatal Magersfontein, and lay down. It was pouring with rain, and there we lay until twelve o'clock at night, when the word was passed along to advance. So we got up—the Highland Brigade—and were marched quietly up to within 300 or 400 yards of their trenches and halted only for a few minutes and then on again.

We were as thick as we could walk in column, and just as we got within a few yards of them they suddenly opened fire on us with at least 6,000 rifles. Such cries I never heard, nor anyone there, of the poor fellows being shot down like sheep.

Major Russell and Sister Rose receiving wounded soldiers on a hospital train at Orange River, 1900. Major A. F. Russell was the Medical Officer with the Royal Scots Greys.

Official estimates would later put the number of rifles at one thousand – the attack triggered by one of the Highlanders catching his foot in a trip wire the Boers had set to warn of advances on their position. After an ensuing period of mayhem, the Scots regrouped and counter-attacked, inflicting heavy casualties on the enemy, but the price they paid was terrible, as the infantryman reported to his friend.

The soldier continued:

> Through this mistake, the Highland Brigade lost over 800 men and our general. We kept the fight up until half-past seven at night, and had to retire through darkness and the want of water, and slept on the veldt. The sight the battlefield presented the next day was terrible. It took us all day to bury the dead, both Boer and British.

It was Major-General Andrew Gilbert Wauchope who was killed, a popular and fearless leader who was idolised by his men. Sources disagree over his

Highlanders from the 1st Battalion The Black Watch stand over the graves of some of their colleagues who fell during the Battle of Magersfontein. The fact that so many were buried so far from home led to the creation of some of Britain's earliest civic war memorials.

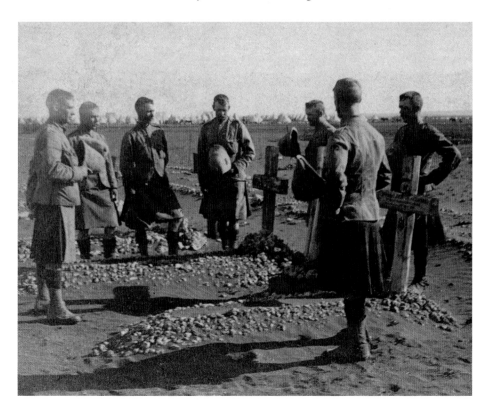

Troops from the Royal Munster Fusiliers under attack from the Boers at Honey Nest Kloof on 16 February 1900. In the trench behind the sandbag redoubt are the bodies of some of the dead and wounded. The Munsters numbered around one thousand men, who heavily criticised the conditions of the camp – while they had plenty of ammunition, there were few rations. One trooper spent twelve months in confinement for saying he would rather fight for the Boers than the British!

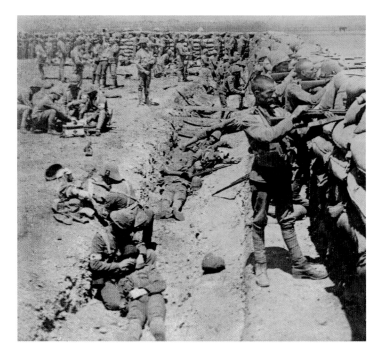

dying words: according to George Brisbane Douglas, he said, 'Don't blame me for this, lads', but Arthur Conan Doyle was more circumspect, saying, 'Rumour has placed words of reproach upon his dying lips, but his nature, both gentle and soldierly, forbids the supposition. "What a pity!" was the only utterance which a brother Highlander ascribes to him.'

Like the Crimea half a century earlier, the South African War demonstrated Britain's limited ability to wage all-out war so far from home, and against a highly mobile enemy who had much better knowledge of the terrain. Significantly, it demonstrated that, despite all the experience of policing the Empire, Britain's generals were far from adept at developing strategies to fight a foe as well armed as they were.

The Boers finally surrendered and signed the Treaty of Vereeniging on 31 May 1902, and although the British had won, it was not without huge costs. Nearly twenty-two thousand British and Empire troops had died – almost two-thirds of them from disease rather than bullets – and the Boers had suffered over fifty thousand deaths.

Over £3 million was spent rebuilding the shattered country, and limited self-government was granted in 1906 and 1907. The two Boer republics, the South African Republic and the Orange Free State, became part of the British Empire, and three years later, the Union of South Africa was formed in 1910.

The unveiling of the Patriotic Memorial in Wilton Lodge Public Park, Hawick, on 23 August 1903, commemorating the twenty-two Hawick men who died in South Africa. The memorial was unveiled by the British commander, Field Marshal Lord Roberts.

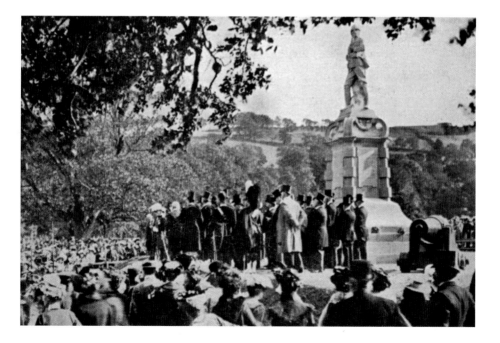

BUILDING A
MODERN NAVY

Aʟᴡᴀʏꜱ one for the pithy sound-bite (generations ahead of his time in that respect), the First Sea Lord, Admiral Sir John 'Jackie' Fisher, when announcing the Royal Navy's major ship-building programme in 1904 coined the motto, 'Build first, build fast, each one better than the last'.

Under his leadership, the Navy built one of the most feared ships of the day, HMS *Dreadnought*. He introduced destroyers as a class of fast and well-armed ships, and despite having many critics, he is remembered as a man who put the Navy first – and the well-being of the men who crewed the ships as well.

The building of HMS *Dreadnought* epitomised his approach. Her keel was laid down in October 1905, and she was launched on 10 February 1906, just four months after her keel-laying ceremony – a remarkable rate of construction for any vessel, let alone for an 18,420-ton battleship. She put to sea in December 1906, after a total build time of only fourteen months,

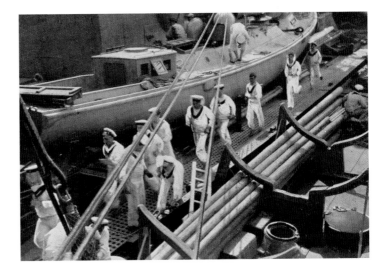

Getting ready for action, on board HMS *Magnificent* in 1904 – from an Edwardian postcard produced as No. 19 in *The Knight Series*, which rivalled Max Ettlinger's catalogue of military subjects produced at about the same time.

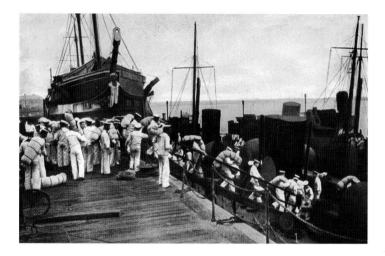

HMS *Magnificent*
was built in
Chatham Dockyard
in the 1890s and
armed on Tyneside.
The 14,900-ton
ship was a 'Majestic
Class' battleship,
armed with four
12-inch and twelve
6-inch guns. HMS
Majestic herself was
built at Portsmouth,
taking twenty-two
months to
complete, two
months less than
Magnificent.

establishing a record which has never been beaten. *Dreadnought*'s armaments were amongst the features which made her special – her ten 12-inch Vickers-built Mark X guns had a range and an accuracy which allowed her to deliver a salvo while well out of reach of the torpedoes which were becoming a common weapon used against warships. The other major advance was the use of huge Parson steam turbines to power her at speeds of up to 21 knots. She was the first Royal Navy ship to be fitted with steam turbines.

By 1908, even *Dreadnought* had been eclipsed – in weight if not in size – by the 'Bellerophon Class' battleships, the first of which, HMS *Bellerophon* herself, was launched at Portsmouth in July 1907. The three ships in the class – *Bellerophon*, *Superb* and *Temeraire* – were

A British warship off Valetta, Malta, c. 1887, shows the ongoing dependence on sail. The masts impeded the warship's fighting ability. The former Chief Constructor of the naval dockyards at Malta, William H. Gard, was instrumental in helping to develop the modern warship.

Europe's navies in the 1880s were still designed on the assumption that sail was a necessary backup to steam power. In this view, photographed in Port Said in the mid-1880s, the French warship Vauban, which entered service in 1883, still uses protective barbettes rather than gun turrets. The barbette protected the gun and its gunners, but restricted the ship's angles of fire. To the right of the picture is the 2,850-ton Gneisenau, a three-masted, iron-hulled fully rigged sailing frigate of the German Kaiserliche Marine, which entered service in 1880. While she had an adequately powered steam engine, those masts and rigging severely limited the gunners' lines of fire.

built at Portsmouth, Elswick and Devonport and, apart from a second tripod mast, were externally almost identical to the Dreadnoughts. Below deck, however, the extra weight was a consequence of fitting improved bulkheads, and above decks, more secondary firepower had been added to improve their ability to fend off attacks from fast torpedo boats.

The Bellerophons were succeeded by the new 'St Vincent Class' battleships, the first of which was launched in 1909. The three ships – St Vincent, Collingwood and Vanguard – were built at Portsmouth, Devonport and Barrow respectively, and at 19,500 tons were the Royal Navy's biggest to date.

This was a period of frantic building – the realisation that the German navy was also building Dreadnought-type battleships was just the spur the Admiralty needed to modernise the fleet. The proposed 'Neptune Class' resulted in only one ship, Portsmouth-built HMS Neptune herself, as a decision was made to increase the armour on the next two ships. HMS Colossus and HMS Hercules were ordered in 1909, and were to be the last of

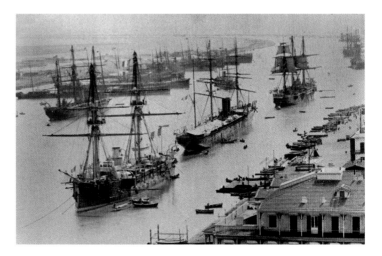

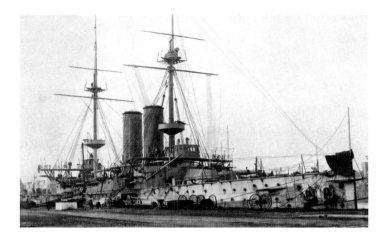

Top: HMS *Albemarle* was laid down at Chatham in January 1900 and completed in November 1903, one of the 'Duncan Class' of lighter battleships, designed for speed, but still heavily armed. Her main armament was four Armstrong-Whitworth 12-inch guns, and six Vickers 6-inch Mark VII guns. Other ships of the class were built at Birkenhead, Devonport, Jarrow, and Thames Iron Works.

Centre: HMS *Sans Pareil* in the floating dry dock at Chatham dockyards, 1902. The floating dock is seen here under test shortly after its completion. Built with a lifting capacity of 17,500 tons, the 10,470-ton *Sans Pareil* was much smaller than the new generation of warships the dock had been built to handle.

Bottom: Within a very few years, warships were already too big for the new dock. Here the workforce at Portsmouth dockyard prepare for the launch of the 19,560-ton HMS *St Vincent* in September 1908.

Top: Two warships nearing completion in the Devonshire Dock, Barrow-in-Furness, in 1903. The Vickers-Maxim works in Barrow manufactured a wide range of armaments for the British Army and Navy. Many of the new warships which entered service in the first years of the twentieth century came out of the yards, as did the first generations of British submarines. Barrow's name is still synonymous with the construction of submarines today.

Centre: Looking across the river towards Armstrong's sprawling Elswick Works on the Tyne, 1904. The 9,800-ton HMS *Lancaster*, a 'Monmouth Class' cruiser, is nearing completion at the quayside. HMS *Lancaster* was the only one of the ten-ship class built on Tyneside. The others were built at Portsmouth, at Pembroke, and at Dalmuir and Govan on the Clyde.

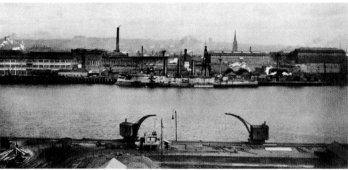

The launch of the 18,000-ton HMS *Lord Nelson* at Palmer's yard on the Tyne at Jarrow on 4 September 1906. She was the last pre-Dreadnought battleship to join the Royal Navy.

Opposite, bottom: The giant gun turrets for Dreadnought-type battleships under construction at Armstrong's Elswick factory on Tyneside, c. 1905. These huge 12-inch guns became, for several years, the standard heavy armament on Britain's most powerful battleships. The gun and turret weighed 46 tons, and they fired 850lb (390kg) shells.

the Dreadnoughts fitted with the Armstrong-Whitworth 12-inch gun. Future generations of 'Super-Dreadnoughts' would have even bigger 13.5-inch main armament.

The pace of the naval arms race was frantic, and the military power map of Europe was changing dramatically. Britain's naval strategies had for a long time been developed assuming that Russia was the major threat – with occasional threats from the French, the last of which in 1898 almost led to

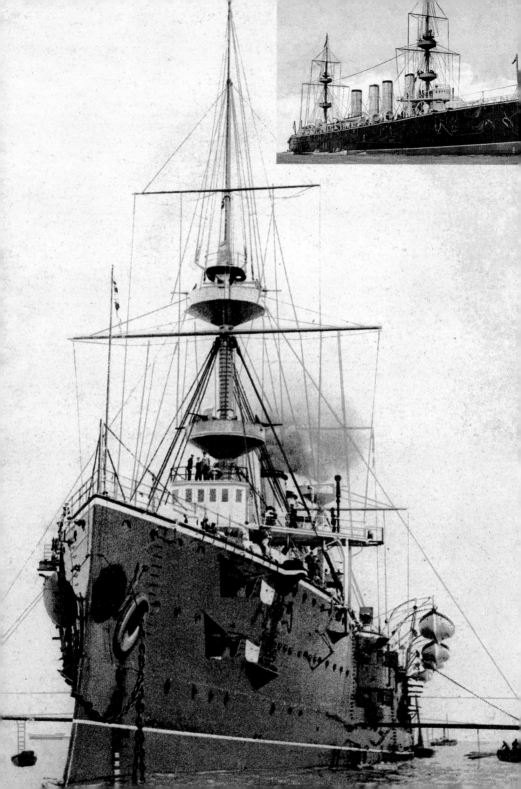

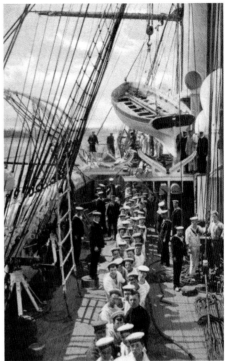

Opposite page: HMS *Terrible*, a 14,200-ton 'Powerful Class' cruiser, was launched in 1895 at J & G Thomson's Clydebank yard. She and her Barrow-built sister HMS *Powerful* (inset) were for a time the largest, fastest and most heavily armed cruisers in the world. She started her service life in the China Seas, and also took part in the relief of Ladysmith during the Second Boer War.

Life in the Edwardian Royal Navy was celebrated in a huge number of tinted postcards, covering just about every activity sailors undertook. Top left, a Gunnery Lieutenant stands alongside his gun, while, top right, the crew of a warship is captured 'Hoisting in the Boats'. The postcard, bottom, is captioned, 'Blue Jackets in Landing Dress'.

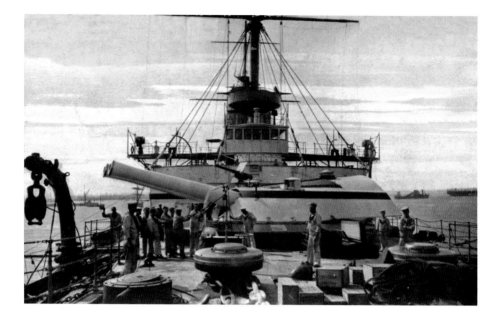

Sailors stow equipment and supplies below decks from the foredeck of a British warship, under the barrels of the massive main guns. This is from a 1908 postcard entitled, 'Fo'castle of a British Warship'.

war over the Sudan. But the growing military prowess of Germany was increasingly worrying to the Admiralty.

Added to that, the 'defeat' of Russia in the short but intense war with the Japanese (many of the Japanese ships had been built and armed in Britain) had reduced the Russian threat. The emergence of a German navy under the direction of Admiral Tirpitz, however, called for a radical rethink of Britain's naval building programmes.

The origins of the Dreadnought class of ships can be traced back to 1882, and an Italian rather than a British concept, but it was Sir John Fisher, with vital input from William H. Gard, who oversaw its development, as previously noted. The speed of HMS *Dreadnought*, coupled with the long range of her guns, made her an awesome fighting machine, and she became the blueprint for the development of most of the world's navies for some years thereafter.

These new classes of warship were born into the era of the picture postcard, and the Edwardian years marked the rapid growth of the postcard-collecting craze. So, every new class of ship became the subject of at least one card, and usually several.

The navy was also experimenting with submarines – although there were a few in the Admiralty who felt such vessels were a rather underhand, un-British, way of fighting a war. Between 1901 and 1905 five submarines were built in Barrow under licence from the Holland Torpedo Boat Company of

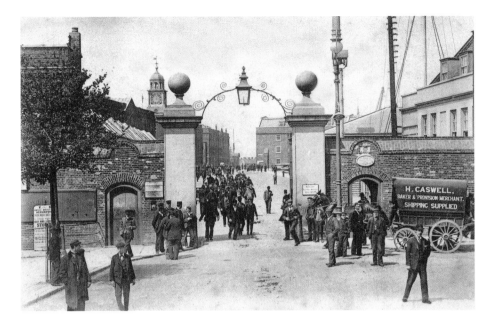

America, but proved to be highly unreliable. The first British-designed vessels – the 'A' Class – were similarly blighted, but the navy persevered with 'B', 'C', and 'D' classes before the end of the Edwardian era, with the 'D' class remaining in production throughout the First World War.

The modern navy was taking shape, although Britain would enter the Great War still with many vessels built to nineteenth-century specifications.

Workers leaving the main gates of Portsmouth Dockyards after the end of their shift. Many of the largest warships commissioned in the early twentieth century were constructed in these dockyards.

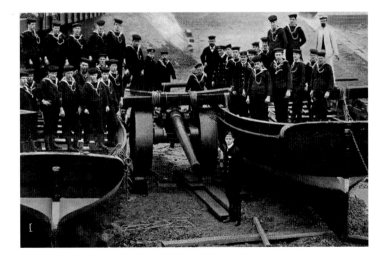

'The Navy – Landing the Big Guns' was one of a series of postcards produced between 1905 and 1910 illustrating the workings of the Royal Navy, which were avidly collected by postcard enthusiasts.

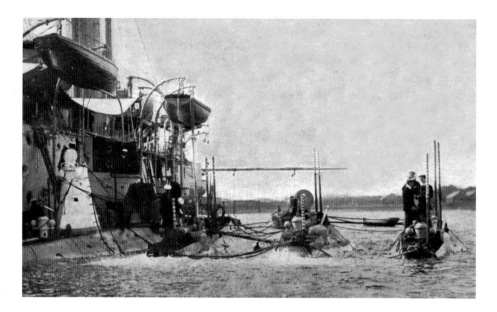

Above: A group of early British submarines moored by a warship, including, closest to the vessel, *Submarine A1*, built by Vickers at Barrow and launched in early July 1902. She was sunk with the loss of all hands after being struck by the SS *Berwick Castle* in the Solent in March 1904, whilst carrying out a practice attack on HMS *Juno*. In all, thirteen of the 'A' class submarines were built, and all suffered some failure. All subsequent Royal Navy submarines were equipped with a watertight hatch at the base of the conning tower.

All of the 'A' class vessels were built by Vickers, and oddly, *A4*, right, was launched the month before *A1*. She too suffered major problems, this time when salt water penetrated the battery compartment and released chlorine gas. Her crew managed to blow the ballast tanks and bring her to the surface, getting off the vessel before she exploded and sank. She was raised and repaired, and operated until 1920.

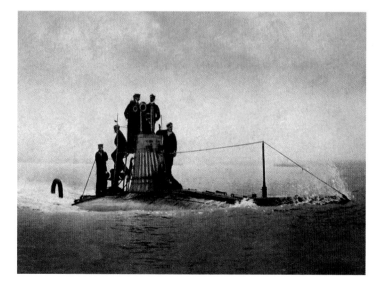

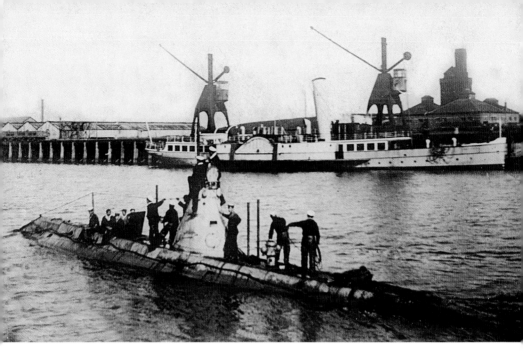

Above: Another view of the submarine A1, this time in the Ramsden Dock at Barrow. This design, however flawed, was an improvement on the 'Holland' class of submarine which the British had pioneered. After her sinking in March 1904, A1 was raised within a month and rebuilt, and this image is believed to date from shortly after she re-entered service. She sank again in 1911 while being used as an unmanned and remotely controlled vessel, her wreckage only being rediscovered in the 1980s. Behind her, tied up at the quay is one of the Furness Railway paddle steamers which sailed between Barrow, Blackpool and Fleetwood. Her sister ship A8 was lost off Plymouth with all hands – a crew of eleven – in 1905, as was A7 in 1914.

Many humorous postcards with a naval theme were marketed during the Edwardian period. This one is simply entitled, 'Sailors off duty on pay day'.

FURTHER READING

There are several fine monographs available on those who pioneered the photography of war. Also included in this list are general books on war photography, many of which may be out of print. Copies of these older general works may be found at www.amazon.co.uk or www.abebooks.co.uk.

MONOGRAPHS

BEATO, FELICE (*c.* 1834–1906)
Harris, David. *Of Battle and Beauty: Felice Beato's Photographs of China*. Santa Barbara Museum of Art, 1999.
Lacoste, Anne. *Felice Beato: A Photographer on the Eastern Road*. Getty, 2010.

BURKE, JOHN (1843–1900)
Khan, Omar. *From Kashmir to Kabul: Photography 1860–1900*. Mapin Publishing/Prestel, 2002.

FENTON, ROGER (1819–69)
Daniel, Malcolm *et al. All the Mighty World: The Photographs of Roger Fenton 1852–1860*. Yale University Press, 2004.

Soldiers of the Royal Engineers Balloon Corps prepare to launch one of their gas-filled observation balloons at Aldershot in 1906. The Army had been using balloons in this way for many years, and had established a School of Ballooning in the late 1880s.

Hannavy, John. *Roger Fenton of Crimble Hall*. Gordon Fraser/David R. Godine, 1975.

Lloyd, Valerie. *Roger Fenton: Photographer of the 1850s*. South Bank Board, 1988.

ROBERTSON, JAMES (*c.*1813–88)

Lawson, Julie. *James Robertson, Photographer of Istanbul*. Scottish National Portrait Gallery, 1991.

Oztuncay, B. *James Robertson, Pioneer of Photography in the Ottoman Empire*. Eren, 1992.

GENERAL WORKS

Burleigh, Bennet. *Khartoum Campaign 1898*. Chapman and Hall, 1899.

Farwell, Byron. *Queen Victoria's Little Wars*. Pen and Sword, 2009.

Hannavy, John. *Great Photographic Journeys*. Dewi Lewis, 2007.

Hannavy, John, and Sweetman, John. *The Camera Goes to War* (exhibition catalogue). Scottish Arts Council, 1974.

James, Lawrence. *Crimea 1854–56*. Hayes Kennedy, 1981.

Kerr, Paul, *et al. The Crimean War*. Boxtree/Channel 4 Books, 1997.

Laband, A., and Knight, I. *The War Correspondents: The Anglo–Zulu War*. Bramley Books, 1997.

Lambert, Andrew, and Badsey, Stephen. *The War Correspondents: The Crimean War*. Bramley Books, 1997.

Lewinski, Jorge. *The Camera at War*. W. H. Allen, 1978.

Scaife, Arthur. *The War to Date*. T. Fisher Unwin, 1900.

Sibbald, Raymond. *The War Correspondents: The Boer War*. Bramley Books, 1993.

Soldiers of the Durham Light Infantry in training erect a bridge over a river in 1904. The scarlet tunics had been restricted to ceremonial use long before this postcard was published as part of Max Ettlinger's series, *Life in Our Army*.

INDEX